P9-BJM-209

Light and Movement in
Watercolour

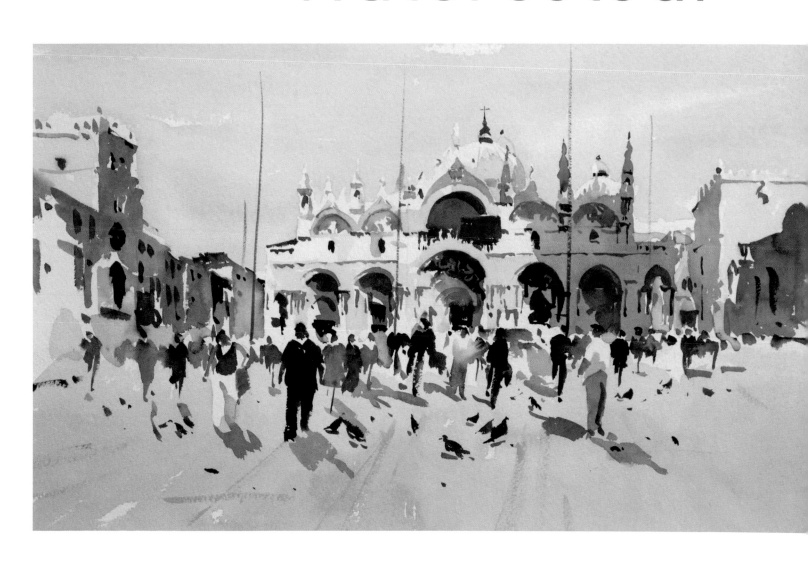

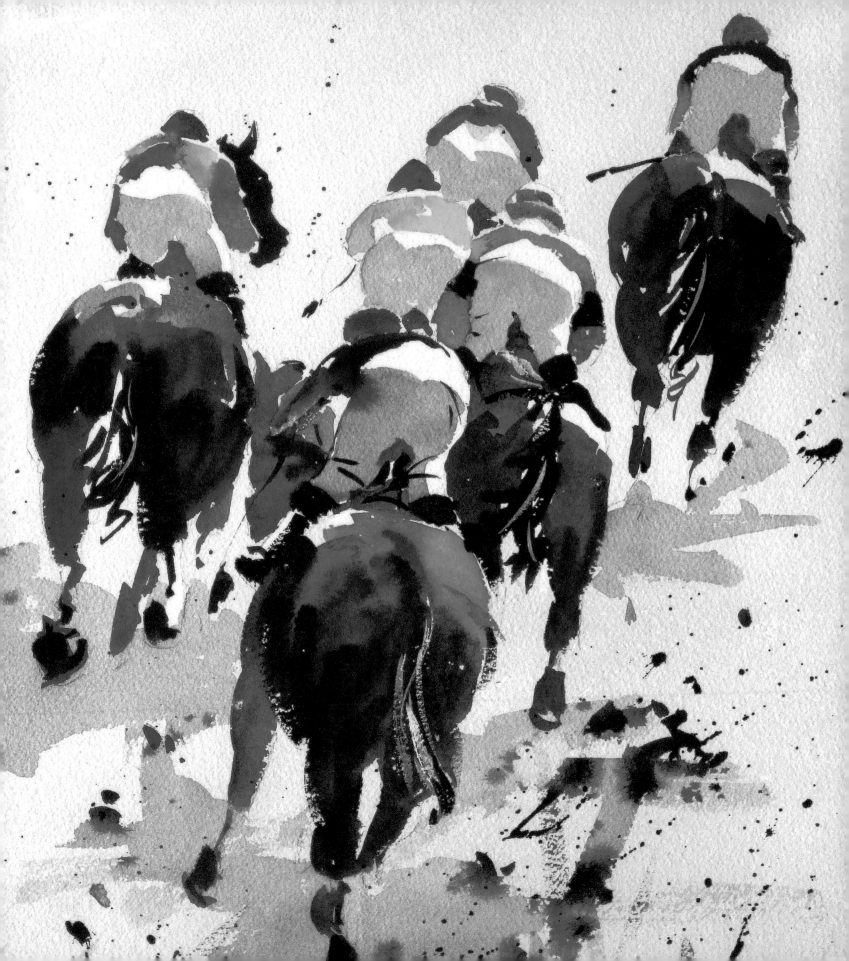

Light and Movement in
Watercolour

JAKE WINKLE and ROBIN CAPON

BATSFORD

**To the memory of my dear mum, Angie, and for my wife
Caroline, for her ongoing support**

www.jakewinkle.co.uk
www.luxartis.biz

**First published in the United Kingdom in 2012 by
Batsford
10 Southcombe Street
London
W14 0RA**

An imprint of Anova Books Company Ltd
Copyright © Batsford 2012
Illustrations © Jake Winkle 2012
Text © Robin Capon 2012

ISBN: 9781849940276

A CIP catalogue record for this book is available from
the British Library.

21 20 19 18 17 16 15 14 13 12
10 9 8 7 6 5 4 3 2 1

Reproduction by Rival Colour Ltd, UK
Printed and bound by 1010 Printing International Ltd, China

Distributed in the United States and Canada by Sterling
Publishing Co., 387 Park Avenue South, New York, NY 10016, USA

This book can be ordered direct from the publisher at the
website **www.anovabooks.com**, or try your local bookshop.

Page 1: **St Mark's Square**
watercolour on Arches 300gsm (140lb) Rough
32 x 46cm (12½ x 18in)

Page 2: **Rear View**
watercolour on Arches 300gsm (140lb) Rough
46 x 32cm (18 x 12½in)

Right: **Hen Pecked**
watercolour on Saunders Waterford 300gsm (140lb) Rough
32 x 46cm (12½ x 18in)

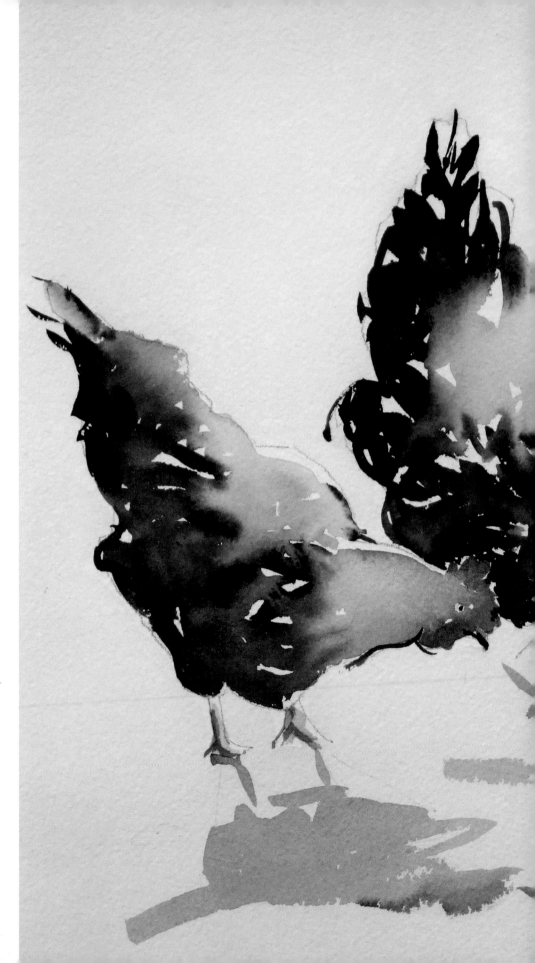

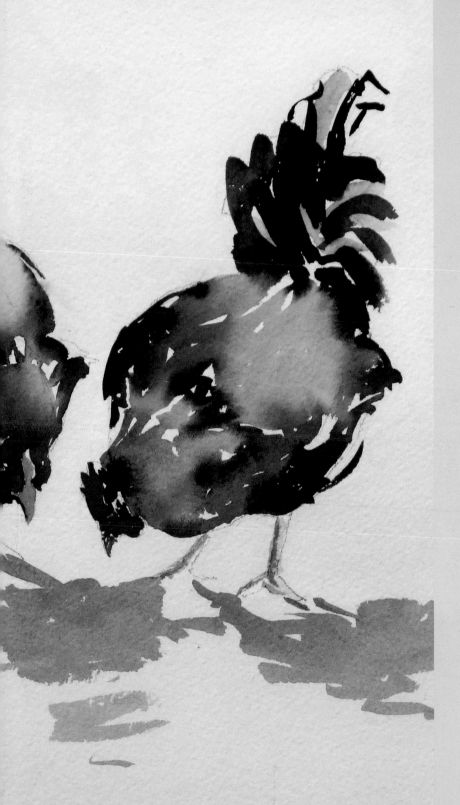

Contents

Jake Winkle in his studio.

INTRODUCTION

Since I started working as a professional artist, almost twenty years ago, I have always painted in watercolour. What I instantly liked about watercolour was the fact that I did not necessarily have to follow a lengthy process to create interesting effects with colour: I could do this quickly, with a single application of paint. Moreover, as I soon discovered, the medium was more versatile than I had imagined. I found there was no reason, for example, why it could not be used as thick, virtually opaque paint as well as in translucent washes. Also, I found that I could get very striking, fresh and colourful results by starting with the dark tones in the subject, rather than following the conventional practice of working from light to dark (applying sequential washes of colour to build up tonal and other effects).

These developments grew out of my initial working process, which was essentially a wet-into-wet technique. This involved working on wet paper and then, as the paper dried out slightly, applying thicker, bolder colours, finishing with colour that was taken straight from the tube. The next logical step was to try this method on dry paper, concentrating on shape and colour, but paying particular attention to the relative tonal value of each colour in the subject.

The Tall Vase
watercolour on Arches 300gsm (140lb) Rough
46 x 32cm (18 x 12½in)

This painting is all about creating a pattern of darks that link together. After the pencil sketch, I started with the dark leaves, which left the outline shape of the flowers – the focal point of the painting. I worked on this area next, then the background, and finally the dropped leaves and tabletop.

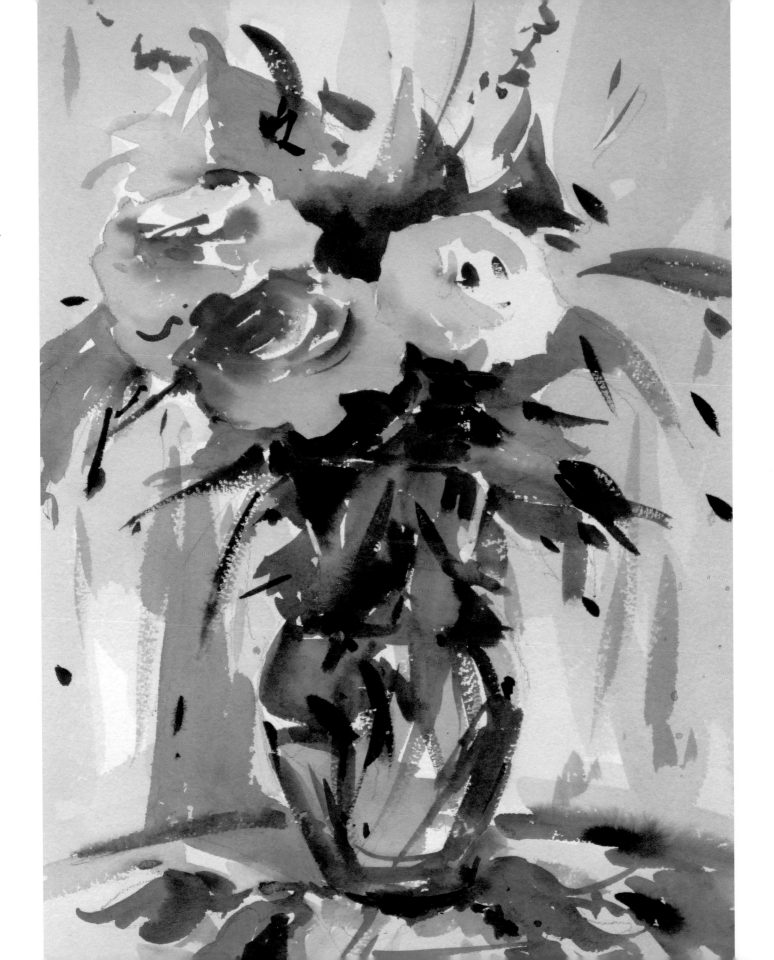

So, having started, as most artists do, by using watercolour in the traditional way – by building up effects and the degree of tonal contrast with a sequence of colour washes – I now began to develop an entirely different approach in which the dark tones are considered first. For me, there were distinct advantages to this method. For example, it was much easier to keep the colours fresh and vibrant, and similarly easier to preserve the light tones and white areas within the painting and so create plenty of impact through tonal contrast. Also, I could judge the tonal relationships in the subject much better by starting with the dark areas, rather than having to begin by reserving the highlights. Essentially, this direct, dark-to-light process resulted in much livelier, more interesting and satisfying paintings.

Success with watercolour relies on confident mark-making, for it is not easy to correct mistakes. In turn, confidence comes from developing a sound painting practice – knowing how to mix colours, how much water to add, how to load a brush with paint, how to hold the brush to create certain effects, and so on. The learning of these basic techniques is fundamental to achieving good results, whatever approach you choose. It is particularly relevant to the dark-to-light approach because this relies on speed, spontaneity and a flow of linked shapes with very little further modification (if any).

Now, the vast majority of my work is painted in this way – dark to light. It is a method that suits all types of subject matter and, as is the aim in my work, captures each subject truthfully but as an impression rather than a detailed study. As I have said, it is a method that requires speed and confidence. But, with the right degree of application and attention to sound painting practice, success with this quite different approach to watercolour painting is eminently achievable. I can vouch for this, having tutored many classes and workshops over the years. For artists of all abilities, the direct method of dark-to-light painting offers enormous potential for expressive, rewarding and successful work.

Fairground Ride, La Rochelle
watercolour on Arches 300gsm (140lb) Rough
25 x 27cm (9¾ x 10½in)

Essentially, I work with shape, tone and colour.
I aim for an impression of the subject rather
than a detailed study.

1 UNDERSTANDING WATERCOLOUR

For me, the attraction of watercolour lies in its immediacy, its freshness and the expressive potential that is possible by exploiting combinations of colour against the white surface of the paper. I also like the fact that it has its own distinctive technique. However, these qualities, which make watercolour such a wonderfully direct and responsive medium to work with, also mean that initially it is not an easy medium to use. With an opaque medium, such as oil or acrylic paint, you can paint over mistakes and adjust and improve the painting as you work. But with watercolour you need to have confidence in the marks and colours you first apply because there is no way of fully resolving mistakes.

In watercolour, the most powerful colour is white. It is the effect of counterchange (created by colours and tones set against the white paper) that produces atmosphere, drama and impact in a watercolour painting. The ability to create that effect relies on first gaining confidence with technique, and by so doing, learning the basic skills in handling aspects such as colour mixing, tonal strength, paint consistency and brushstrokes. Here, the key to success is practice. The more you practise, the more familiar you will become with, for example, how much water to use in a colour wash, or which colours to mix together to make the particular colour you need. Eventually, these basic skills will become second nature. Then there is more time to think about the qualities that will make your paintings personal and individual – qualities such as simplification and interpretation.

Old Harry Rocks
watercolour on Saunders Waterford 300gsm
(140lb) Rough
46 x 32cm (18 x 12½in)

This was an ideal subject for watercolour –
one in which I could make use of lots of white
paper punctuated by strong accents of colour.
I applied two colour washes, one over
another, to create the sense of depth and
variation in the foreground sea area.

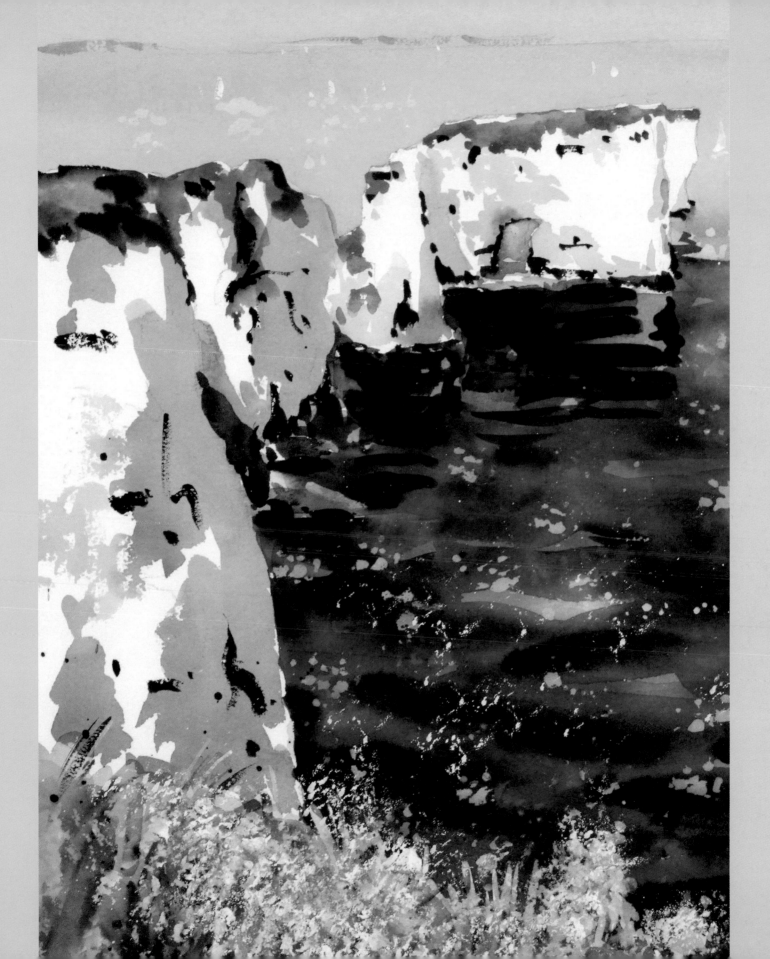

A direct medium

The traditional approach to watercolour is to work in layers, using a sequence of colour washes, a process known as working from light to dark. The aim is to exploit the translucency of the medium, yet at the same time develop variations of tone and 'reserve' the white areas of the paper – either by using masking fluid or by simply not applying any paint to those areas. The danger with the layered method is that paintings can so easily become overworked and in consequence lose much of their impact.
I prefer to take a different approach, one that I think is more straightforward and effective.

Watercolour is actually a very versatile medium. The character of the finished painting is principally determined by whether you work on dry, damp or wet paper, the fluidity of the colours used and the techniques chosen to apply them. In fact, when I first used watercolour I worked in a fairly traditional way, essentially with a wet-into-wet technique (see page 41), applying thicker paint as the work progressed. I particularly liked the contrasts that could be achieved with light and shade in this medium, and also the expressive nature of the brushstrokes. But, as I discovered, with the layered approach the subtlety of the brushstrokes is soon lost.

Assisi
watercolour on Arches 300gsm (140lb) Rough
32 x 46cm (12½ x 18in)

Typical of my dark-to-light approach, the most important areas in this painting are the shadows. If you can imagine the painting with just the shadows, it would still make sense.

Brian
watercolour on Arches 300gsm (140lb) Rough
35 x 25cm (13¾ x 9¾in)

I never deliberately limit my colour palette.
As shown here, in this portrait of my father,
if there are few colours, this has been
determined by the subject matter itself.

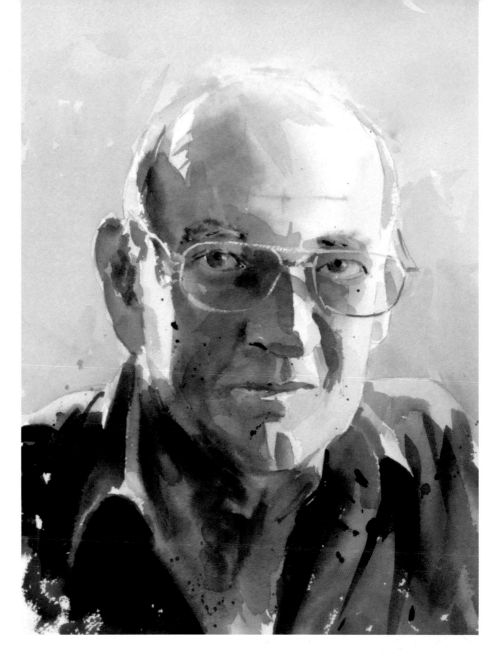

I wanted to preserve that subtlety and create as much drama as I could in each painting. Because of this, I began to develop a more direct approach that relied on assessing and painting the correct tone as a single wash, rather than building up the tonal value with a sequence of washes. So, with this method the darks are painted straight away; there is no preliminary underpainting. This 'dark-to-light' approach is a more spontaneous way of working, with the advantage that you can start wherever you like, and you don't have to start with the lightest tones. By linking passages together through their tonal values, the painting develops with a better structure and a greater sense of immediacy and drama.

It is quite difficult to judge a light tone against the white of the paper – it is much easier to judge a very dark tone. Painting on dry paper and with reference to that first dark tone you applied, you can quickly move on to put in relatively similar tones, fusing edges wet-up-to-wet (see page 41), although as necessary changing the colour as you work your way around the painting. The medium-value tones are added in the same way, with the lightest tone left as the white of the paper. To help with this approach, my advice is to look at the subject matter through half-closed eyes, as this will simplify and identify the main tonal values.

The aim is to create pathways of dark and medium tones across the painting, placing simplified shapes quickly and developing them with lost and found edges. When I paint, it is not about painting one object and then moving on to the next one, it is about painting complete tonal areas as linked shapes. Also, I like to exaggerate colour slightly, rather than interpret it in an exact, realistic way.

Capturing the essence

Watercolour is an ideal medium for capturing an impression of a subject. This is the way I like to work because it is quick, spontaneous and encourages results that are evocative and exciting. There is no reason why a detailed painting shouldn't look equally stunning, of course, but for me it is the essence of a subject that is important and the fact that a certain amount is left to the viewer's imagination.

When people first start painting they often feel obliged to represent everything in front of them and include as much detail as possible. This is a natural reaction: it takes time to appreciate and acquire the skills necessary to develop a response that involves simplification and interpretation. But in fact we cannot see everything in detail all at the same time: some things are

Mara Lion
watercolour on Arches 300gsm (140lb) Rough
32 x 46cm (12½ x 18in)

Here, every brushstroke counts in helping to describe the form and character of the subject. The white spaces count too; very often in a painting it is not just the parts that are filled in with colour that are important, but equally the parts that are left unpainted.

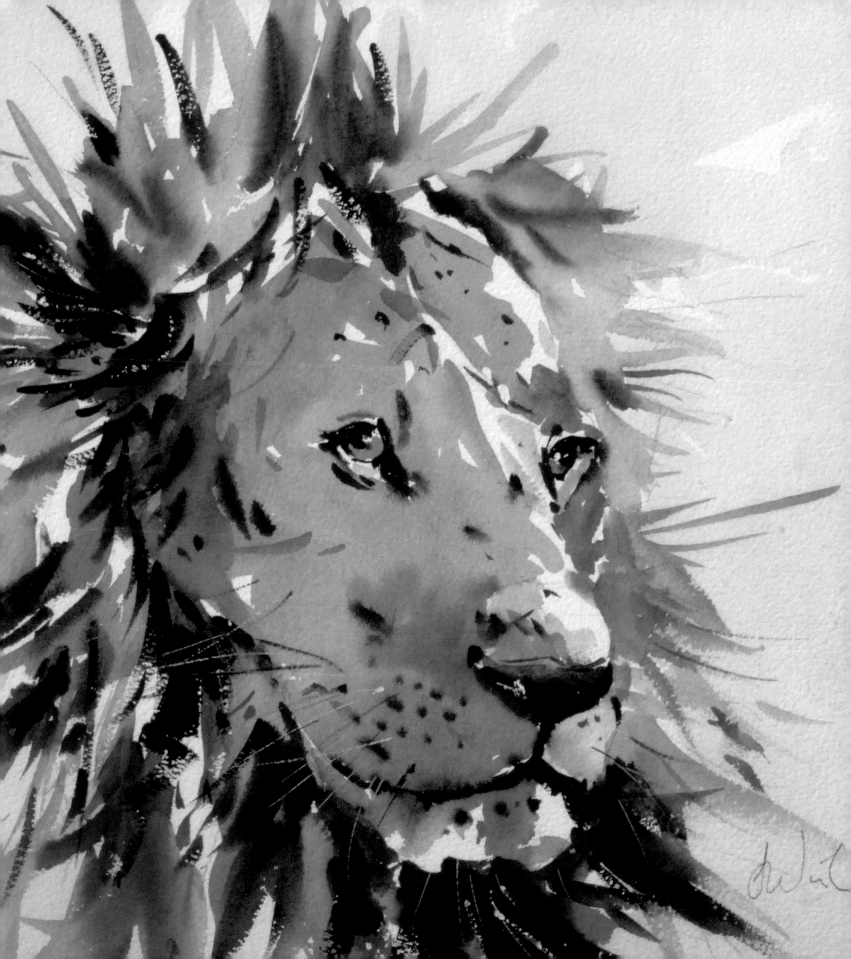

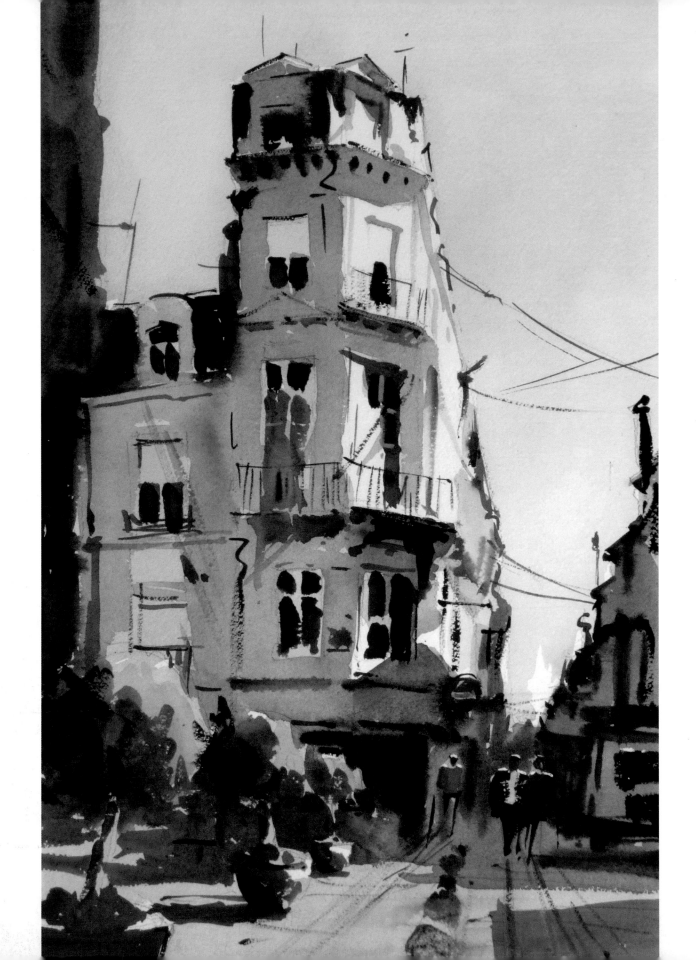

in focus; some are not. We need to embody that idea in our paintings. If, on the other hand, we were to take each area of a subject in turn and paint it in detail, this would, in effect, create a series of small paintings within a larger one. It would probably result in a painting that is too 'busy' – one that lacks a particular focus and impact.

As I have suggested, a good technique to help judge tonal values is to half-close your eyes, and equally this helps to identify the essence of a subject. By half-closing your eyes it is much easier to see which shapes, details, colours and tones stand out and consequently are important to the subject, and which are out of focus. For example, when you look at a tree through half-closed eyes, the main shapes and tones are emphasized rather than the detail in the leaves.

The conventional practice in painting is to make the most important element – usually the feature that initially attracted the artist to the subject – the focal point. The viewer's interest is led to this point by means of a carefully devised composition; additionally, it is in this area that we find the strongest colour and tonal counterchange as well as the most detail. This way of working, building a composition around a focal point, is a reliable method to begin with. It helps both in creating paintings that have a sound structure and in focusing on the essence of the subject.

Angers
watercolour on Arches 300gsm (140lb) Rough
46 x 32cm (18 x 12½in)

Essentially, paintings are created from a relationship between shapes – usually principal shapes, such as the buildings in this painting, and shadow shapes.

The Della Salute
watercolour on Arches 300gsm (140lb) Rough
32 x 46cm (12½ x 18in)

This subject required quite a complex drawing to begin with, then in the painting I concentrated on working with lost and found edges and abstract patterns to create the sense of the buildings.

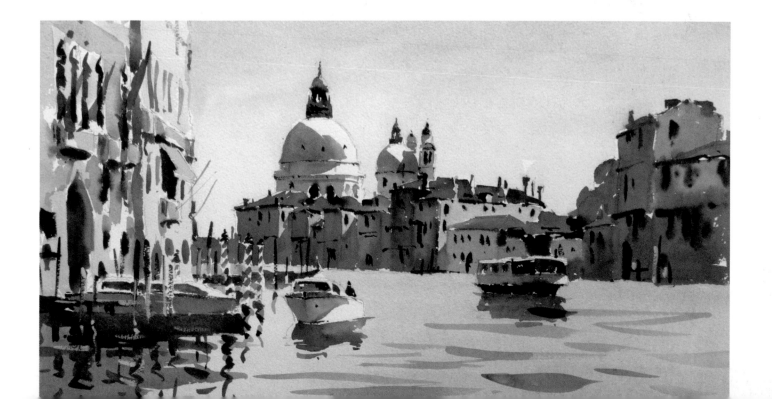

I sometimes concentrate on a single image, effectively the focal point, in the form of a vignette painting, as in *Mara Lion* (pages 14–15). In other paintings, for example street scenes such as *Angers* (page 16), I use 'lead-in' features to direct the eye to a focal point. However, the approach I prefer is to have no particular focal point but instead to encourage the eye to wander around the whole painting, as in *The Della Salute* (page 17). And in fact I don't always know what the essence of a subject is when I begin painting. Often it is the painting process itself, the dark-to-light approach, that defines the essence of a subject. See also Content and Composition, page 103.

Traditional Paris
watercolour on Arches 300gsm (140lb) Rough
46 x 32cm (18 x 12½in)

I like to start each painting with the part that most excites me about the subject, which in this case was the main shape of the building. Note that the foliage in the foreground, which is of less importance, is softer in treatment and slightly out of focus.

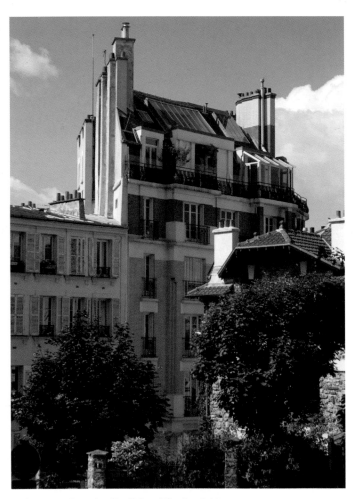

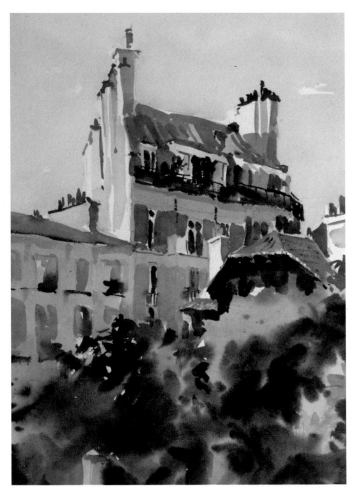

Reference photo for Traditional Paris, right.

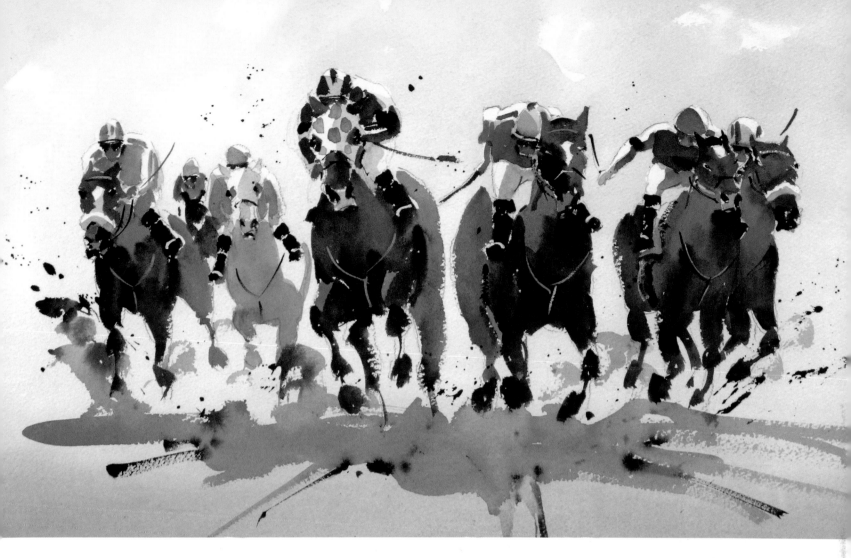

Finishers
watercolour on Arches 300gsm (140lb) Rough
32 x 46cm (12½ x 18in)

This is one of my vignette paintings, in which
I focus entirely on the main subject matter and
set this against a simple background made
from one or two broad colour-washes. As
here, it is a particularly good technique when
you want to create a sense of movement.

Qualities and potential

Watercolour is not for the faint-hearted! Being a quick, expressive medium,
it usually demands an intuitive approach, as once you have started there is
little time for considered thought and deliberation. It is an excellent medium
for interpreting different qualities of light, in particular transient
atmospheric effects. Success with watercolour relies on painting fluently
and having confidence in the marks you are making.

I know from my own experience that sometimes the marks I make on paper
are not exactly those I had in mind. But equally, I know there is little value in
judging a painting until all the marks are in place. A watercolour painting is
the sum of its components, and although it is built from individual marks,
it is the final, overall relationship and effect of those marks that determines
the degree of success. Obviously, some paintings work out better than
others. If a painting is unsuccessful, it is usually due to the choice of subject
matter, rather than ineffective technique.

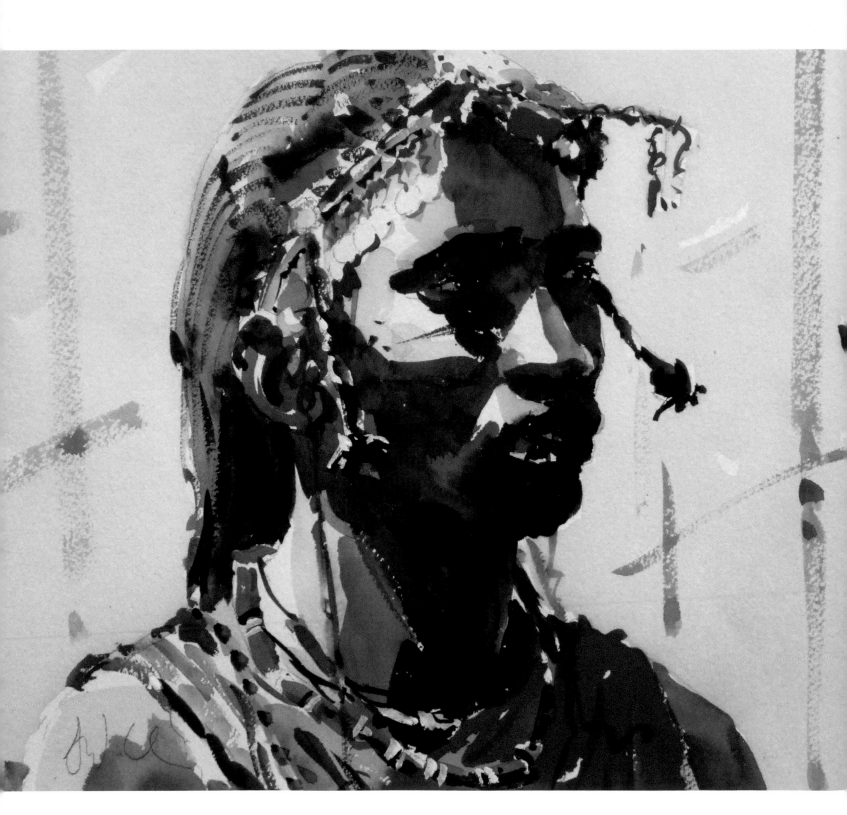

The essential equipment for watercolour painting is compact, lightweight and portable, and this makes it an excellent medium for *plein-air* painting. I sometimes paint outside, but I also work from a wide range of reference material (sketches, photographs and images from various sources) as well as from imagination. I have no concerns about using photographs for ideas because, as with any form of information, my aim is not to copy but to interpret. As you can see from *Traditional Paris* (page 18), the reference for which was a photograph, I am not a photorealist. The overriding consideration in any painting is a sensitivity to the medium and technique.

Usually, the impact in my watercolour paintings relies on suggestion rather than detailed representation, and on variety and contrast in the use of colour and tone. Equally, these factors determine qualities such as light, mood and movement in the painting. *Finishers* (page 19) is a good example: it is all about power and movement. Had I included more detail, it would have greatly undermined the sense of movement. So I decided not to have any background, which would have fixed the horses in a certain space, and similarly I kept the detail of hooves, faces and so on to a minimum.

Again, with *The Chief's Son* (page 20), the aim was to suggest as much as possible with as few marks as possible. For portraits, I prefer to use a light source from the side so that there are strong shadows, which will define the contours and features of the head. Any detail within these shadows is just lightly touched upon rather than positively stated. I work with a combination of soft and hard edges, painting wet-up-to-wet (see page 41).

The Chief's Son
watercolour on Arches 300gsm (140lb) Rough
32 x 46cm (12½ x 18in)

Once again, it is the tonal contrasts, the effect of light and shade, that define form and add interest in this painting. With portraits, I like to use a light source from one side, to give strong shadows that will emphasize the features and structure of the head.

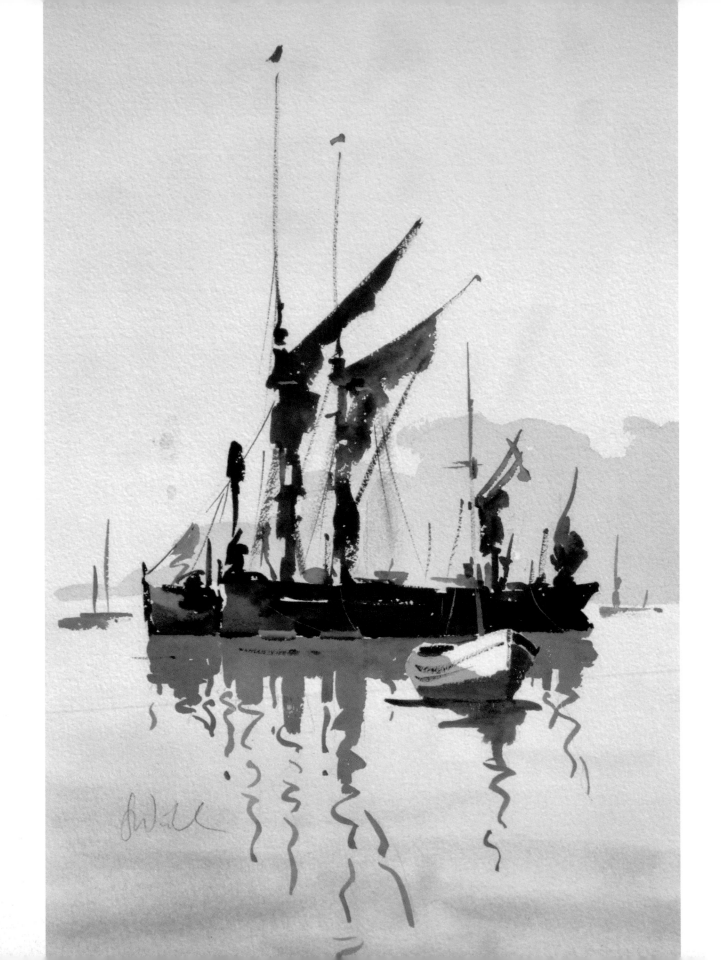

Calm Reflections
watercolour on Arches 300gsm (140lb) Rough
46 x 32cm (18 x 12½in)

This is a much more atmospheric painting, mainly working with mid-tones and silhouetted shapes.

Steam at Swanage
watercolour on Arches 300gsm (140lb) Rough
32 x 46cm (12½ x 18in)

As here, in most of my paintings the work is quick, intense and spontaneous. There is a lot happening in this painting, but the rhythms of lost and found edges and tonal values link everything together.

Materials and equipment

An advantage of watercolour is that you need only a few materials to get started and, apart from stretching the paper, there is no preparation required. The essential materials are paper, paints and brushes, and my advice is to buy the best quality that you can afford. The first materials you try won't necessarily be the most suitable for you, so don't be afraid to experiment with a greater variety of colours or with other types of paper and brushes until you find those that are the most helpful in creating the effects you want in your paintings.

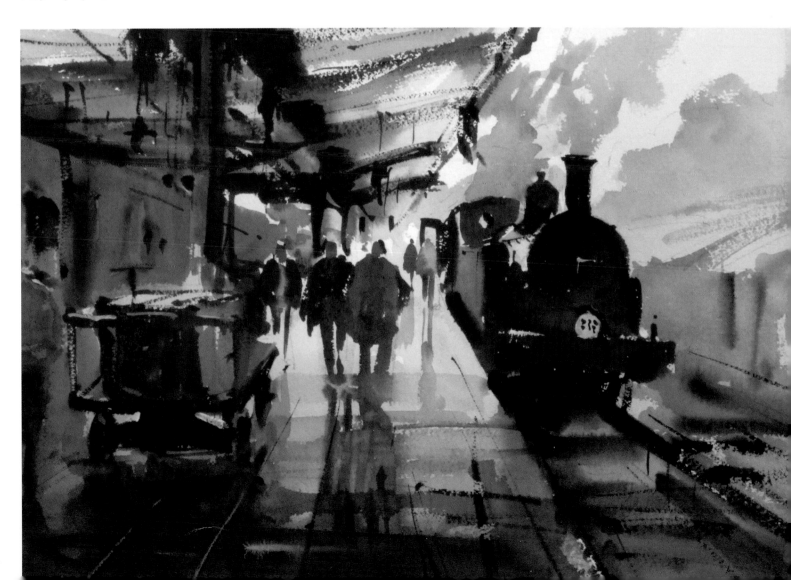

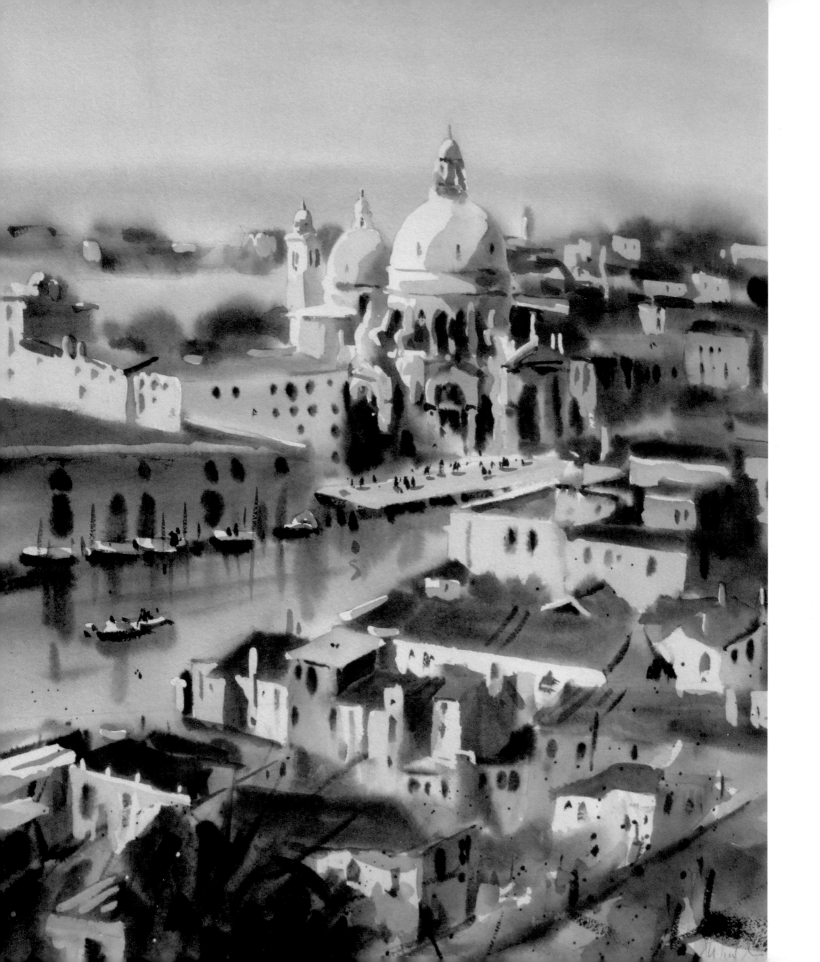

From the Campanile
watercolour on Arches Aquarelle 300gsm
(140lb) Rough
72 x 52cm (28½ x 20½in)

Arches paper absorbs colour evenly but stays wetter for longer than most other brands, which makes it perfect for large, quite complex wet-into-wet paintings such as this.

Paper

The weight, texture and quality of the paper will influence the way it responds and consequently the marks and effects that can be achieved. There are many different types of paper available, with different surfaces. A popular paper with beginners is Bockingford 300gsm (140lb) Not, which is a useful general-purpose paper that will allow colour to be lifted out and consequently mistakes to be corrected to a certain degree.

However, my preference and recommendation is for a more absorbent paper, one that will start absorbing colour immediately and evenly across the whole painting surface. For me, this quality is essential, because I like to work on dry paper with expressive brushstrokes, and I want these to hold their shape without the danger of back-runs or 'cauliflowers'. This can happen when wet paint is applied into or next to other wet paint. Absorbent, rough-textured papers are less conducive to back-runs than smoother, highly sized ones – so I prefer Arches Aquarelle 300gsm (140lb) Rough for most of my work. If the subject does not rely so much on expressive brushwork, I sometimes use Saunders Waterford 300gsm (140lb) Rough. For comparison, look at *From the Campanile* (opposite) for which, being a large, fast, wet-into-wet painting, I chose Arches paper, and

My essential equipment, including a stretched sheet of watercolour paper on a board and my Craig Young palette.

My brushes include a hake (far left), several Luxartis kolinsky sable brushes, and a large squirrel mop.

Old Friends (right), which is a more sketchy painting that doesn't rely so much on controlled brushstrokes.

I always stretch the paper. Usually, I stretch several sheets at the same time by first soaking the paper in clean water for between 30 seconds and 15 minutes – although in my experience the length of time doesn't seem to make any difference to the end result. I then place the paper on a drawing board, sponge off the surplus water and tape down the edges with strips of 5cm (2in) brown gummed tape. I staple through the tape at intervals of about 12.5cm (5in) to ensure that the paper does not lift as it dries. Then I leave it to dry. Most of my paintings are on half-imperial sheets, 38.7 x 57.2cm (15¼ x 22½in).

Paints

I use a Craig Young folding metal palette together with artists' quality tube colours. For working quickly and expressively on a large scale, it is essential to have a palette with deep mixing wells that will hold a generous amount of colour. Tube colours are best. They are more moist and workable than hard pan colours, which makes it easier and quicker to mix the colour washes.

The Craig Young palette incorporates a series of smaller compartments in which to set out the selection of colours you want to work from. For each new painting, I start with fresh colour in all the compartments – a pea-sized amount. I may not use all the colours, but I like to have them readily available. You can never be sure when you are going to need a certain colour. There could be a surprising colour in an area of reflected light, for example, and it is an advantage if you can react to that quickly.

My colours are French ultramarine, Winsor violet, Winsor blue (green shade), cobalt blue, cadmium orange, raw sienna, lemon yellow, light red, alizarin crimson, cadmium red, burnt umber, Winsor green (blue shade), cobalt turquoise light and sepia. Occasionally I add others, such as opera rose or permanent rose, if they are needed for the subject matter.

Old Friends
watercolour on Saunders Waterford 300gsm (140lb) Rough
32 x 46cm (12½ x 18in)

I find Saunders Waterford a very suitable paper for a looser approach that doesn't require any dry-brushwork effects and when I am not too concerned about back-runs. Here, I worked with lots of wet paint and lots of bright colours.

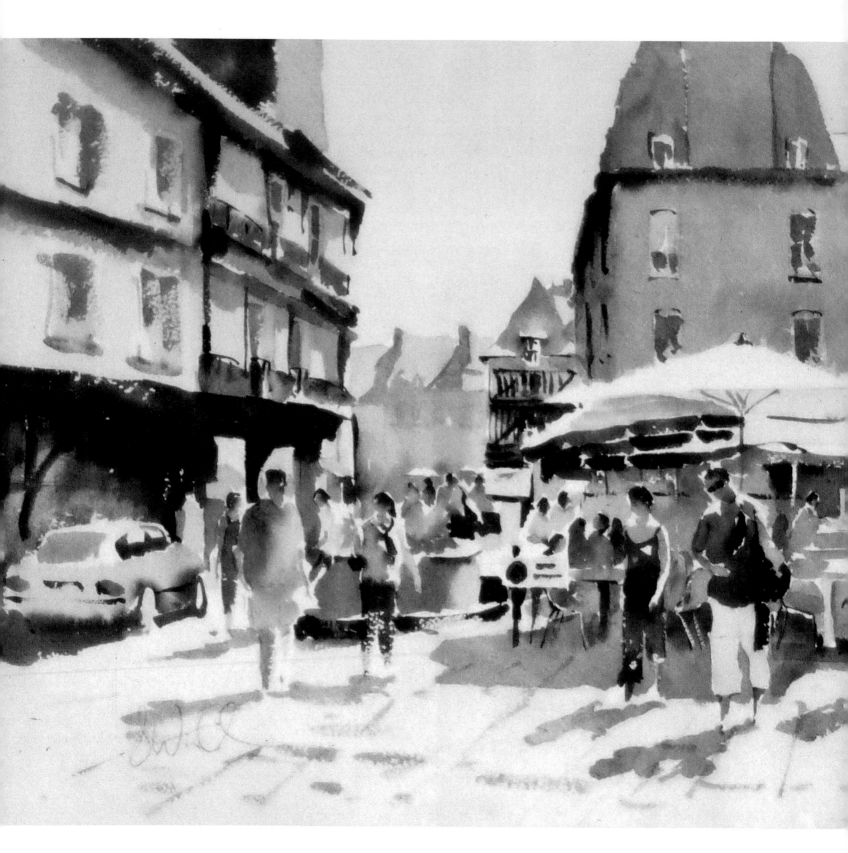

The aim, with this colour palette, is to give me as much scope as possible to reach all regions of the colour wheel. So the emphasis is on primary and secondary colours rather than earth (tertiary) colours. Of the earth colours, I mainly use raw sienna and sepia. My advice is to have a wide colour palette, and then you can mix any colour you want. You can still work with a limited palette if you wish, but if you always restrict yourself in this way it is bound to prove frustrating for some paintings. If your budget is limited, start with a selection of primary and secondary colours. See also Effective Colour, page 52.

Brushes

In my view, there is no substitute for good-quality sable brushes. If you can only afford one brush, my advice is to buy a size 12 sable (equivalent to a size 16 in the Luxartis range that I use). These brushes will hold a lot of paint and because they 'point' well, they can be used for a wide variety of effects, from thin lines to broad washes. In comparison, synthetic-hair brushes are relatively stiff and won't hold as much paint.

My brushes include a hake, for initially wetting the paper; a squirrel-hair mop, which I use for painting large sky and foreground areas; a size 16 and a size 18 (Luxartis) kolinsky sable, which I regard as the most useful brushes, because they suit a wide range of techniques (I use them for most of a painting); and a small, round sable and a rigger, for highlights and details.

The only other essential items are a water pot and some paper tissues for absorbing moisture from the brush. I never use paper tissues to lift out colour from a painting. You cannot create a clean shape that way, and also the process of lifting out leaves a different surface texture, one that encourages colours to bleed and form back-runs. I fill my water pot right to the top. By doing this I can instinctively feel how far the brush is going into the water and therefore how much water it is picking up – the amount of water in the brush is a crucial factor in achieving the right colour mix and paint consistency for your purposes.

Dinan Café
watercolour on Arches 300gsm (140lb) Rough
32 x 46cm (12½ x 18in)

Watercolour is the ideal medium for capturing a fleeting moment and the sense of atmosphere in a subject, as here.

2 BUILDING CONFIDENCE

From the choice of subject matter to the use of appropriate techniques and the handling of colour, there are many factors that contribute to the success of a watercolour painting. Consequently, the painting process can seem very complex at first, because there are so many things to think about at the same time. Understandably, for beginners, this sometimes encourages a rather tentative approach, as they try to ensure that every mark is valid and made to the best of their ability. Yet in fact it is precisely the opposite approach that will bring the greatest progress and success. I accept that it is not an easy thing to achieve – it requires the right mindset – but what is necessary from the outset is confidence in the marks that you are making.

Confidence comes from practice and perseverance, but equally it relies on building a sound understanding and experience of the fundamentals of watercolour painting – what I would call good painting practice. By this I mean concentrating on the following points: getting used to working with a large brush whenever possible; fully loading the brush with colour; learning how to govern the way that paint flows from the brush (the different responses you can achieve according to how you hold the brush and the pressure applied); and, as I have said, having faith in your mark-making.

For fresh, lively watercolours, it is essential to keep brushstrokes to a minimum and to avoid overpainting or attempting to alter anything. Unlike painting in oils or acrylics, it isn't possible to make radical changes to marks and washes made in watercolour. So you need to feel positive and accept them – and move on to the next area. Of course, there may well be parts of a painting that you are not pleased with, but don't feel tempted to rework those areas because it will usually do more harm than good. Keep in mind what went wrong and try to put that right in future paintings. In this way, you will learn something from each painting and so gradually build up knowledge, experience and confidence.

Street Party, Estepona
watercolour on Arches 300gsm (140lb) Rough
46 x 32cm (18 x 12½in)

Bustling with activity and enjoying dramatic light effects, this was an ideal subject. It had all the elements that I love to paint – buildings, shadows, colours and figures, giving lots of scope for confident mark-making.

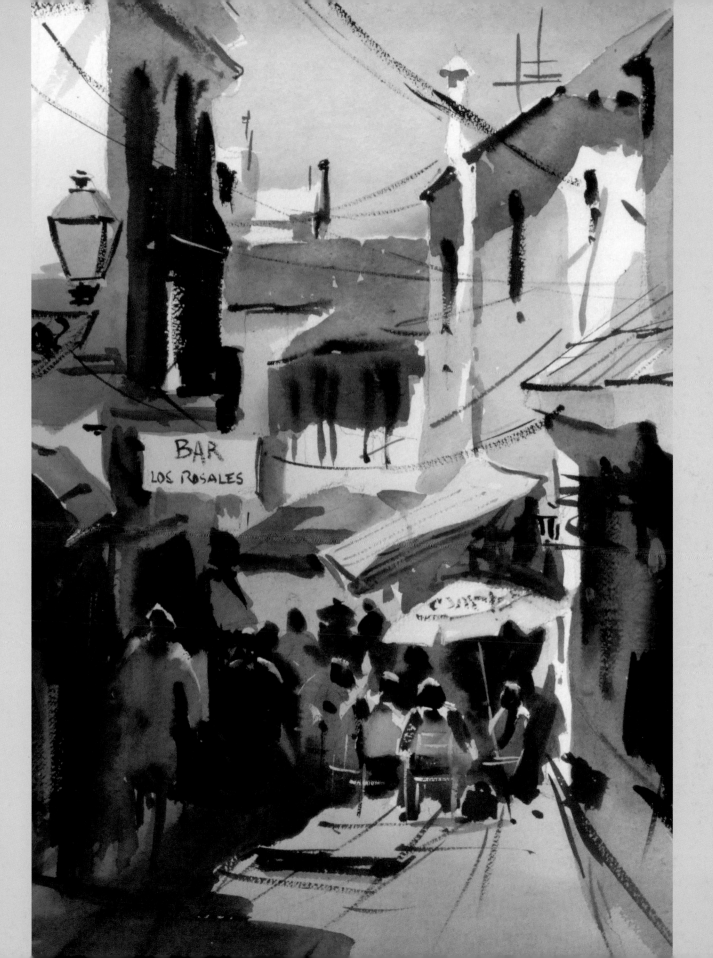

Drawing

While I believe it is essential that every painting should be underpinned by a strong drawing, I do not regard drawing skills as a necessary prerequisite to painting. Obviously, it is an advantage if you are able to draw competently and produce exactly what you need as a foundation drawing from which to develop a painting. But if your drawing skills are limited, I see no objection to using methods such as tracing, or gridding and enlarging, to make a drawing. In my view, the most important thing is the way that you express yourself with paint – a drawing is just a means to help achieve this.

Artists have always used mechanical aids to help with aspects such as drawing, perspective and composition, and so there is no reason why today's artists shouldn't use scanners and computers to modify or enlarge photographs and then make tracings. I draw almost everything freehand, but occasionally, for speed, I might trace something. Always make drawings as quickly and as simply as possible, so leaving yourself with plenty of scope and sufficient energy to interpret the subject as a painting.

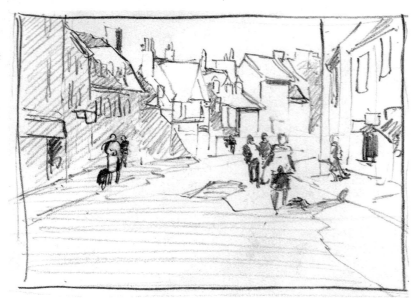

Along East Street, Blandford
sketch on cartridge paper, 10 x 15cm (25½ x 38in)

For my sketches, I draw in pencil, concentrating on the main shapes and the shadow areas. Then, when I come to work from the sketch in the studio, I know instantly where the light is coming from and the essential three-dimensional form of everything.

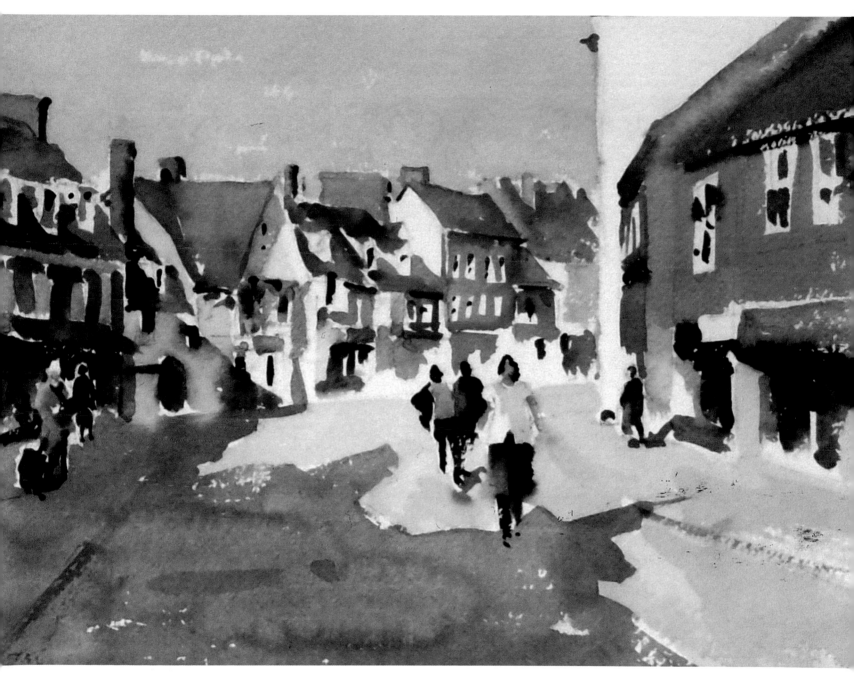

Along East Street, Blandford
watercolour on Arches 300gsm (140lb) Rough
25 x 35cm (9¾ x 13¾in)

With street scenes such as this, I look particularly at the roof line and
the scale and positioning of the figures to help create a sense of depth.

Reference sketches and colour notes

Photographs are a useful source of reference, but try not to rely on photographs alone. Whenever you can, make a small sketch as well. Sketching is a good way to record what you consider to be important: your personal response to a subject is what matters in a painting, but this won't necessarily be captured in a photograph. For my sketches, I use an A5 spiral-bound cartridge pad and a 2B pencil. I keep the sketches simple, indicating the main tonal values and perhaps adding some notes about colours. The *Boston Skyline* sketch (below right) is a typical example of this approach. When, later, I start working on the painting, I like to have the freedom to exaggerate the colours, so I never rely on a coloured sketch or colour photographs alone.

Sketching also helps in developing skills in observation and, of course, drawing. I used to do a lot of rather analytical 'measured' drawing – carefully estimating angles, the relative scale of things, and so on. But in recent years, because speed is essential for me, I have concentrated on contour drawing, in which I focus principally on silhouettes and the shape of spaces. The other important reason I make sketches is to explore different compositional

Boston Skyline
watercolour on Saunders Waterford 300gsm (140lb) Rough
32 x 46cm (12½ x 18in)

This was the painting I made later, from the sketch shown below and with some added reference from a photograph. I decided on a wet-into-wet technique, which I felt would be the best way to integrate the buildings and convey the sense of scale and complexity.

Boston Skyline
sketch on cartridge paper
10 x 15cm (4 x 6in)

I made this quick sketch from the Prudential Tower in Boston. It was a complex subject, looking down over part of the city. My aim in the sketch was to reveal the light buildings by juxtaposing them with darker ones. I have used a sort of drawing shorthand, just concentrating on lines and areas of shading.

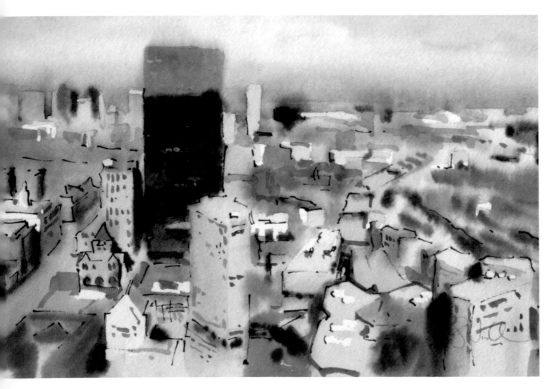

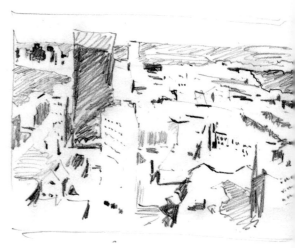

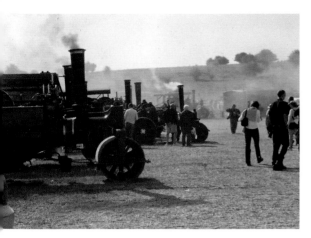

Reference photograph for Dorset Steam, shown right.

Dorset Steam
watercolour on Arches 300gsm (140lb) Rough
32 x 46cm (12½ x 18in)

The biggest steam fair in Europe is held just outside my home town of Blandford Forum in Dorset. There are always many exciting subjects to paint, and this is a painting that I made from the photograph shown above. Note how I have kept the ground area pale, to add emphasis to the steam engines. I have also altered the grouping of the figures to help create a more contained and interesting composition.

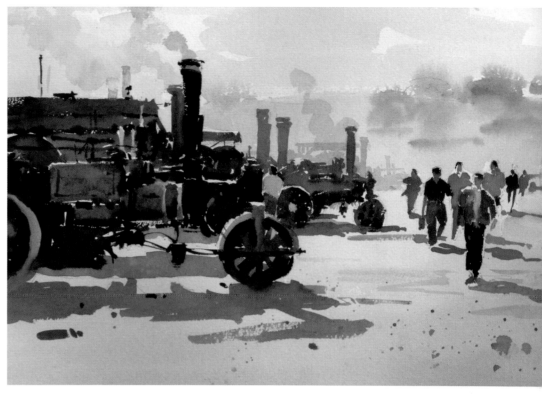

ideas. I make these sketches no larger than 10 x 12.5 cm (4 x 5 in). If I want to adjust the balance of a composition within the bounds of a sketch, I simply rub out the line that I have drawn to define the edges of the sketch and move it to a different position.

Photographs

Photographs are a wonderful resource for painters. They capture the moment, jog the memory and provide information, although as I have said, it is best to back them up with a sketch. I am now also beginning to work from video film, which captures a much better impression of movement. When you are taking photographs, my advice is to pay particular attention to the composition that you want for the painting, although you may have to reposition figures if they are included in your subject.

However, photographs have their limitations. For instance, they give everything the same importance. Also, the subtlety of colours is often lost, especially the variations of colour and interest within shadow areas. In fact for me this is not a problem, because I don't need the amount of detail that some artists might need. And this is particularly so with animal photographs,

Step by step: Cathedral Close, Salisbury

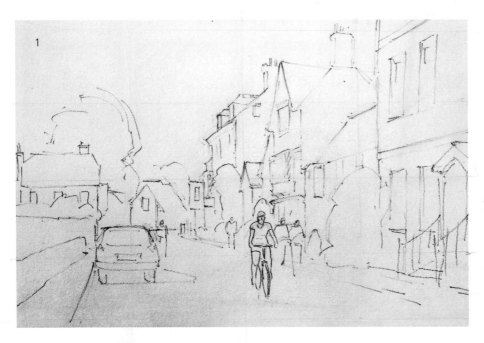

1 For the initial drawing on the watercolour paper I normally use a 2B pencil, keeping to light marks and outlines. I regard the drawing as a guide rather than a target, and much of it will eventually disappear into the painting.

2 I start with the darks, in any area that inspires me. Here, I decided to start with the dark tree shape on the left, which I felt would give me a good lead-in to the painting.

3 Now, as you can see, I am working away from the starting point, linking shapes together as I go, painting wet-up-to-wet, and varying the colour as necessary.

Cathedral Close, Salisbury
Photograph for reference.

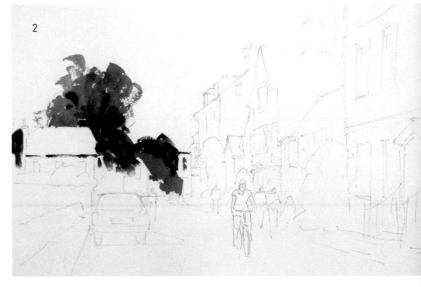

because for animals I am more interested in movement than anything else. Whatever the subject, I like to be faithful to it – to include everything in the painting, although in a simplified way.

Foundation drawing

For a foundation drawing on watercolour paper, the basis for a painting, I use a 2B pencil and I work from the central area outwards, concentrating just on the main shapes. By starting in the centre, I ensure that the focal point is where I want it to be, even if the composition ends up larger or smaller than I had anticipated. Most of the drawing will eventually disappear into the painting. However, I don't mind if the drawing remains visible in places because it shows that it acts only as a guide. It is subservient to the painting process: it does not define it.

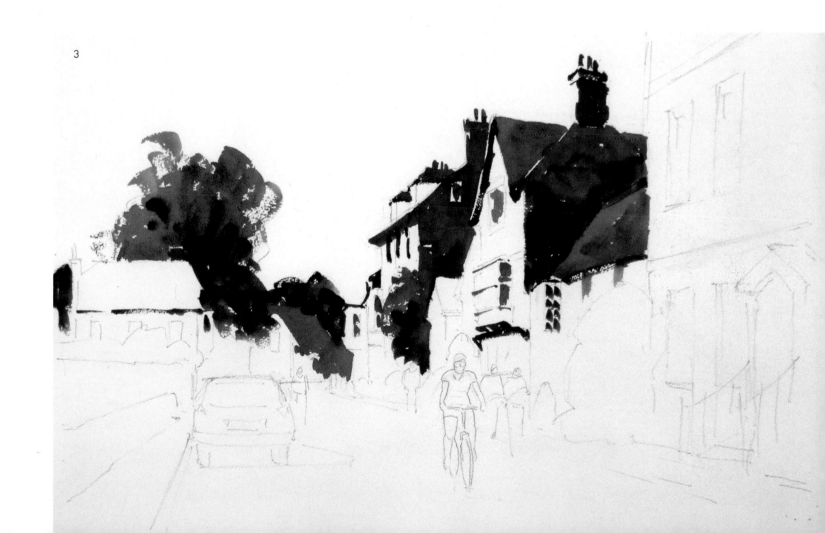

3

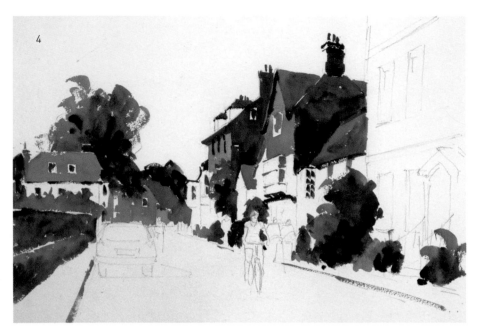

4 I work very quickly, trying to link as many shapes together as I can and, in doing so, completing all the dark areas. This creates a sequence of lost and found edges and also defines the light source and light quality.

5 The painting is left to dry before I add the sky and foreground area.

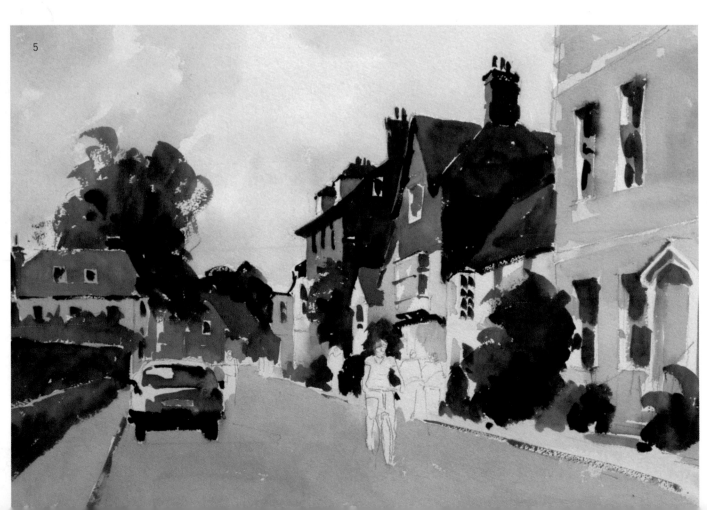

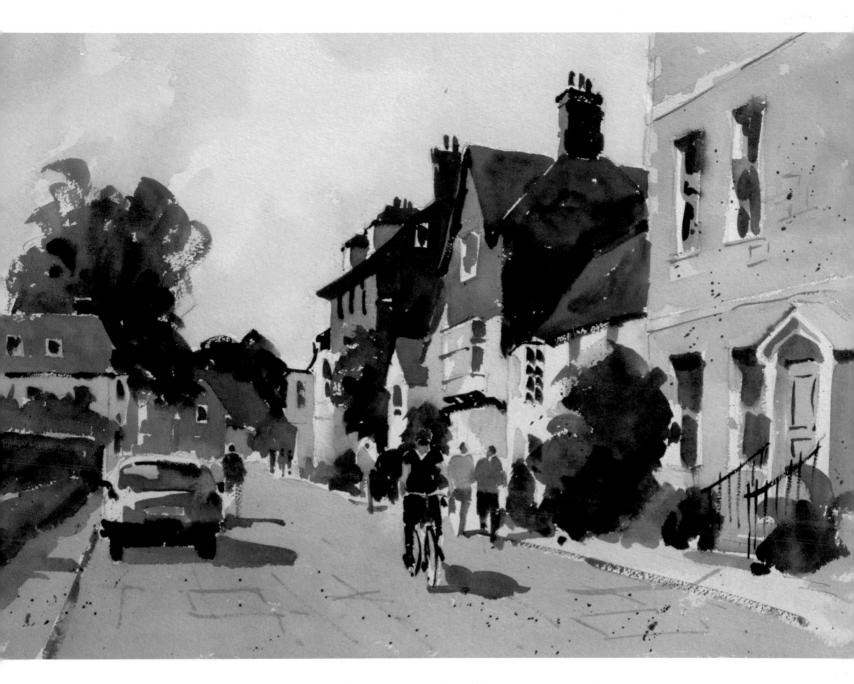

Cathedral Close, Salisbury
watercolour on Arches
300gsm (140lb) Rough
32 x 46cm (12½ x 18in)

Finally, I add the figures, foreground shadows and one or two details.

To aid the sense of life and movement in the painting, I usually hold the brush about two-thirds of the way down the handle. This encourages swift, freely expressed marks and adds interest and impact to the work. Because I paint from dark to light, linking shapes together, I am not confined to working in the conventional way, starting with the distant parts and finishing with the foreground. I start with whatever part most inspires me, which in *Cathedral Close, Salisbury* (above) was the dark trees on the left. You can see, from the step-by-step illustrations, how I developed this painting from the foundation drawing.

Marks and washes

The way that paint is handled – the use of expressive marks and washes – is fundamental to the success and impact of a watercolour painting. Consequently, what is important initially is learning how to hold, load and control a brush, how to adjust the consistency of the paint, and how to apply those skills to create different mark-making effects.

It is essential that the brush is fully laden, which means dipping it and turning it in the colour wash so that all the hairs are coated. Brushmarks can vary from sensitively drawn or calligraphic marks to much broader strokes or blocks of colour, depending on the size of the brush and how it is held and used. If the brush is held like a pen, the marks will be very controlled. If the brush is held much further up the handle or perhaps even at the tip of the handle, the movement will be from the arm rather than the wrist, and so the marks will be much freer and more expressive. Applying pressure to the brush will make the mark broader and heavier; equally, the marks will be influenced by the paint's consistency, which might vary from a thin wash to something resembling rich cream. See below for some useful exercises for beginners to start with.

Simple exercises like these can help to build confidence. *Top left:* Make various calligraphic brushmarks. *Top right:* Hold the brush horizontally, near the end of the handle, and make vertical 'dry' strokes, for textures such as foliage. *Middle:* Dry brushstrokes like these are useful for certain textures and effects, such as in foreground areas. Either use a brush with a lot of fairly dry paint (that is with not much water in the mix) or, using a weaker colour wash, partly dry the brush by touching it on a paper tissue. *Bottom left:* Use wet (but not runny) colours to paint shapes wet-up-to-wet. *Bottom middle:* Vary the pressure on the brush to give thin and thick brushstrokes. *Bottom right:* Practise the wet-in-wet technique. Paint a square of colour, then quickly add more colour to it and keep the process going for as long as you can, until the surface is dry and no longer workable. If you work quickly and manoeuvre the paint around all areas, you should be able to keep the area workable for about 15 minutes.

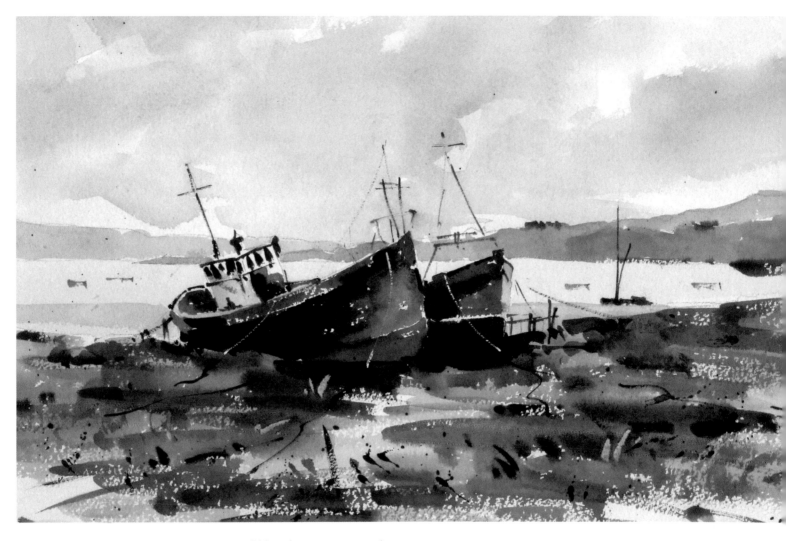

Fishing Boats at Salen
watercolour on Arches 300gsm (140lb) Rough
32 x 46cm (12½ x 18in)

Here is an example of the use of horizontal dry brushstrokes to add interest and texture to the foreground, yet in a way that does not detract from the main subject of the boats.

Wet-into-wet and wet-up-to-wet

I paint wet-into-wet only occasionally. *Cheetahs* (page 43) and *Gondolas at the Salute* (page 44) are two examples of this technique. Wet-up-to-wet, on the other hand, is a technique that I use all the time: it is fundamental to my dark-to-light painting process. Although the two techniques sound and look similar, there is a big difference between them.

When I paint wet-up-to-wet, I work on dry paper, painting up to an area of colour that I have already applied, so that the two colours touch. Where they touch, the colours will merge slightly, creating a 'lost edge'. However, because the paper is dry, the majority of the colour remains unaffected –

there is no diffusion or weakening of the colour. Also, any edges that do not touch remain sharp and defined, and this contrast between 'lost' and 'found' edges will add interest and impact to the painting.

The wet-into-wet technique gives a softer, more atmospheric blended quality to a painting. With wet-into-wet, colour is applied to damp or wet paper and so the intensity of the colour is reduced and the colours tend to fuse together. A feature of wet-into-wet is that it creates very soft edges – the only exception being in those areas that have been protected with masking fluid.

I felt that wet-into-wet was the ideal approach for *Cheetahs* (opposite), mainly because of the background – I wanted all the undergrowth to disappear into the distance. This was an instance when I did use masking fluid (for the tree), but otherwise all the painting was made wet-into-wet, starting with wet paper. I began with some pure blue for the shadow areas of the cheetahs, blending that with a soft orange colour for the fur and subsequently blending that area into the background, so there were no hard edges to define the cheetahs against the background, and this gave a more harmonious effect.

With wet-into-wet, I start with very thin washes in pale colours, and then gradually increase the thickness of the paint as the work progresses. As the painting begins to dry, I add more defined marks and details with thicker paint. Also towards the end, once the wet-into-wet process has been completed, I remove the masking fluid, if I have used it, and finish the work in that area – as with the tree in *Cheetahs*.

Cheetahs
watercolour on Arches 300gsm (140lb) Rough
46 x 32cm (18 x 12½in)

The wet-into-wet technique was particularly suitable for this subject, to help convey the idea of the animals being hidden in the undergrowth. As always with this technique, I started by wetting the entire paper with clean water (having protected the tree shapes with masking fluid) and then worked from applying soft, diffused colours to gradually defining shapes using thicker paint.

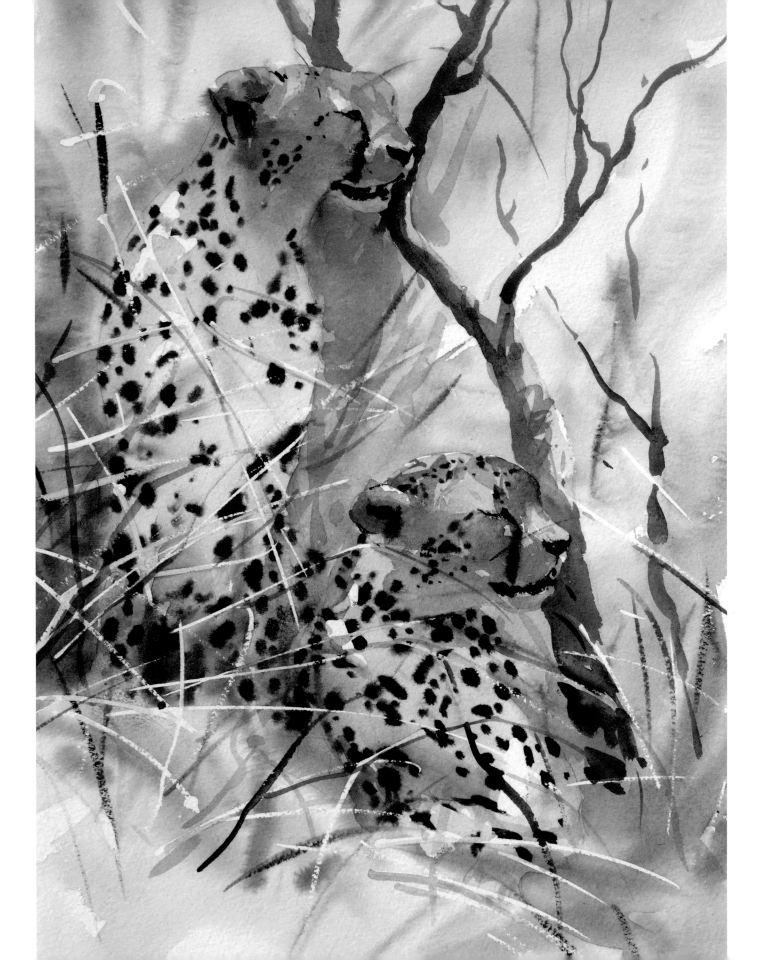

Blocks of colour

I like to concentrate on the use of colour rather than thinking in terms of texture and detail, which for me would be a distraction and draw attention away from the impact of the shapes. So, usually, I work with blocks of colour linked together. These effectively form an abstract pattern of colour running through the painting, although from the viewing distance (the distance at which a viewer of the displayed painting will stand), this resolves itself into the specific shapes of the subject matter. The blocks or areas of colour are

Gondolas at the Salute
watercolour on Arches 300gsm (140lb) Rough
46 x 32cm (18 x 12½in)

This is another wet-into-wet painting, apart from the two gondolas in the foreground, which were added after the painting had dried. Because the gondolas are hard-edged, they come forward and push everything else back.

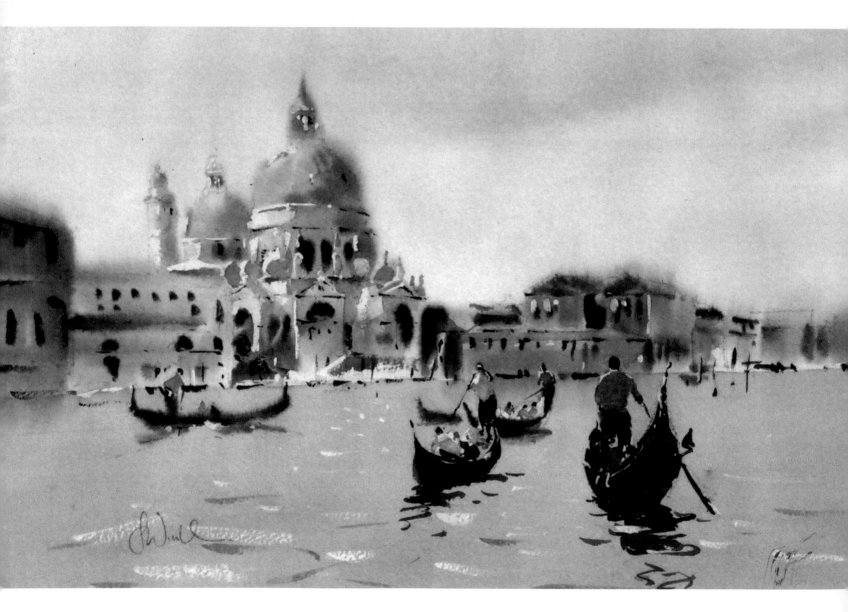

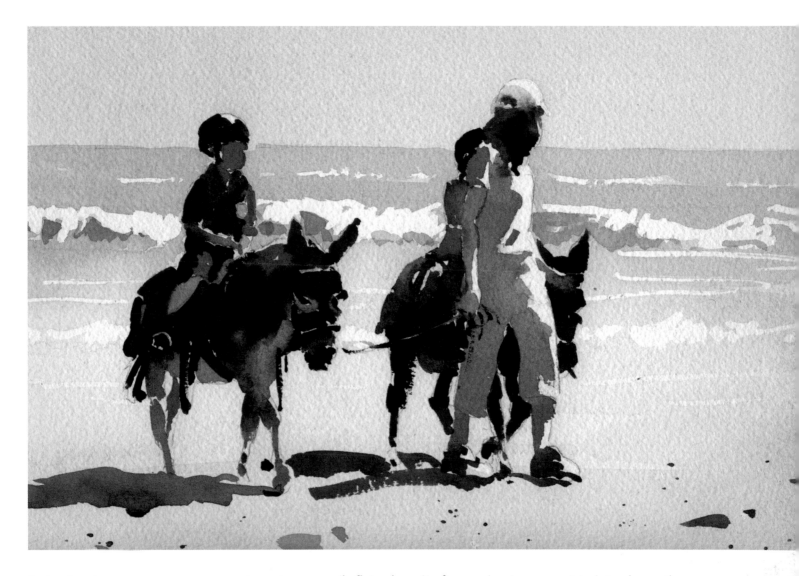

Donkey Patrol
watercolour on Arches 300gsm (140lb) Rough
25 x 35cm (9¾ x 13¾in)

I concentrate on the essential darks, lights
and colours. As you can see here, all the main
shapes are made from interlocking or
superimposed blocks of colour.

not necessarily flat colour: it often varies. I may want to introduce other
colours, perhaps to suggest a shadow or a change of tone, while the paint
is still wet.

Donkey Patrol (above) demonstrates this technique. All the main elements
were made from interlinking or superimposed blocks of colour. For example,
with the main figure – the lady leading the donkeys – I started with the
shadow on her hat, which linked straight away into her hair and the shadow
down her side. Her entire body was one continuous wet-up-to-wet wash, but
with the colour changing all the time.

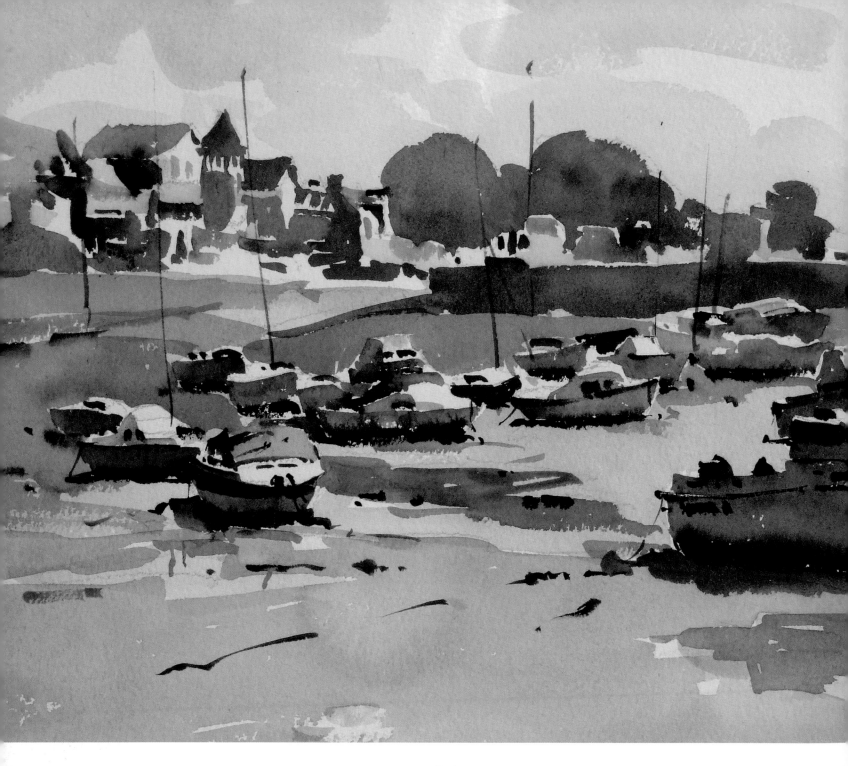

Pornic
watercolour on Arches 300gsm (140lb) Rough
32 x 46cm (12½ x 18in)

For creating a sense of distance, I generally use cool colours rather than weak colours. This means that I can include objects in the background that are relatively dark (a cool dark) and so create pathways of darks throughout the painting.

Spring Bouquet
watercolour on Arches 300gsm (140lb) Rough
46 x 32cm (18 x 12½in)

The shape of spaces is always important. The white flowers and the side of the vase are key 'space shapes' here, but there are also more subtle ones in the background.

Shapes and spaces

In every painting, I am very conscious of the interaction between shapes and spaces. They are both equally important in creating a composition that is interesting and effective. In *Your Highness* (page 49), for example, I deliberately chose to have some parts of the head touching the edges of the picture area because I knew that this would divide up the background in an interesting way. Had I made the head smaller, with a single unbroken space around it, the result would have been far less effective – it would have lacked the strength and drama of the composition that I chose. And, as with the markings on the giraffe, shapes within shapes add further interest.

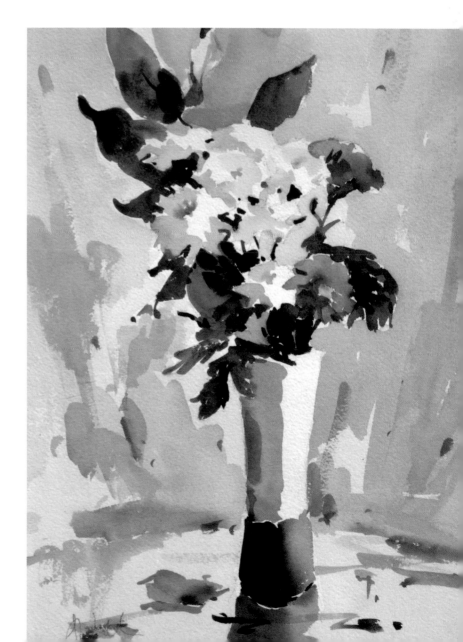

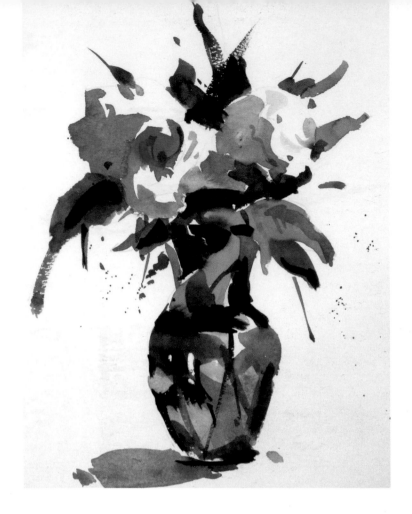

Flower Sketch
watercolour on Saunders Waterford 300gsm
(140lb) Rough
35 x 25cm (13¾ x 9¾in)

This was a study for another painting, The Tall
Vase (page 7), although this is something
I rarely do. I have explored various
counterchange and counterbalancing effects
with the light, colour, shape and so on.

Your Highness
watercolour on Arches 300gsm (140lb) Rough
46 x 32cm (18 x 12½in)

Working on dry paper, I used a wide variety of
techniques in this painting, including drawing
with the brush, calligraphic marks and dry
brushwork, and wet-up-to-wet colour of
different consistencies.

A successful composition must include areas of 'rest', which are usually the spaces (also described as 'space shapes') or low-key colours, as well as areas of interest and activity. It is the way that these different areas are arranged, balanced and contrasted that determines the particular character and impact of the painting. As with all aspects of painting, the composition shouldn't look contrived, although it is only after gaining some experience that it is possible to work in a more intuitive way. The key things to avoid in a composition are repetition, symmetry and anything that creates an unwanted distraction or looks very awkward – someone standing in front of a lamp post that appears to grow out of their head, for example!

For centuries, the Golden Section or Golden Mean has been the guiding light for many artists with regard to planning a composition. This is a principle of proportion in which (when applied to the basic division of a sheet of paper or a canvas, for example) the ratio of the smaller area to the larger is the same as that of the larger to the whole. It is expressed in numerical terms as a ratio of 5:8, although artists often further approximate it into a division of thirds – so making the focal point of their composition roughly one-third or two-thirds of the way across the picture's surface. This division is often referred to as the 'rule of thirds'.

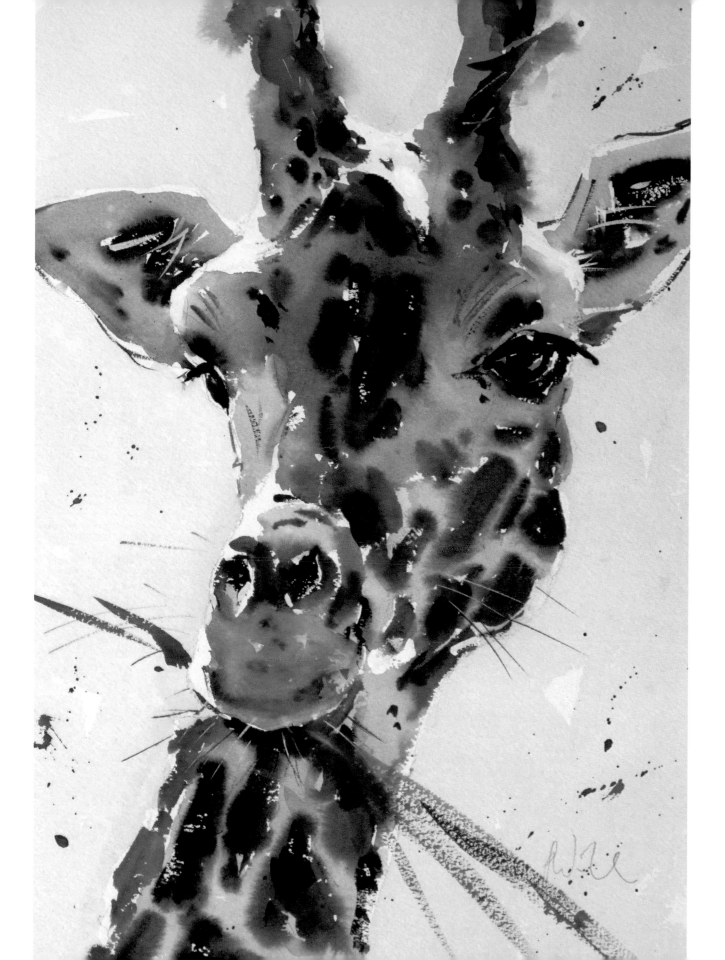

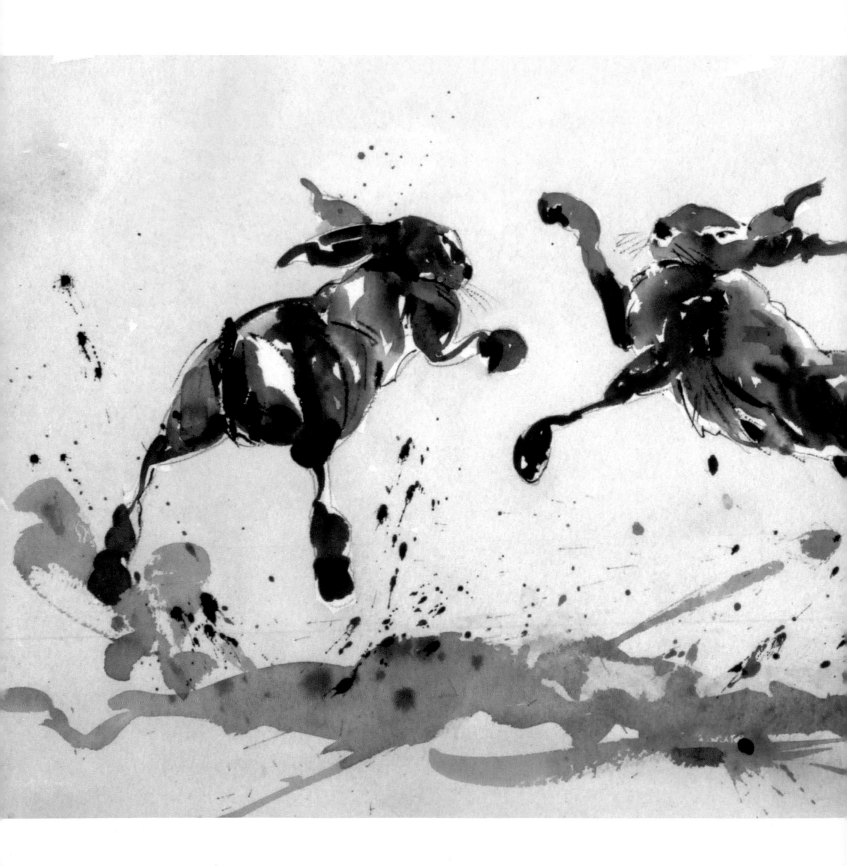

I prefer a less formal approach. I think that as long as you realize that the focal point (and, incidentally, I don't always have a specific focal point) should be somewhere around the central third of the picture area, and that other shapes need to be spaced irregularly, then the composition should work well. I often use what I think of as a see-saw arrangement for a composition. For instance, I might include a very big shape just to the left of the centre of the painting, counterbalancing this with a much smaller shape on the far right, as in *Dorset Steam* (page 35).

Contrast and harmony

In addition to the play of contrast and harmony created by the shapes and spaces of a composition, there are other elements that will similarly add to the drama and impact of a painting. These include the counterchange effects of light and dark or the use of cool and warm colours, as well as contrasts in painting techniques, perhaps between wash and dry-brush effects, for example, or lost and found edges. Here, again, I like to work intuitively, so I adapt and include things according to the way that the painting is developing and what I feel it needs.

Several of these points are demonstrated in *Flower Sketch* (page 48). There are counterchange effects throughout this painting, particularly those created by the contrast of the strong, dark foliage shapes with the very light background area. As you can see, the roses themselves are formed from positive against negative shapes, colour against space shapes, with the one shape revealing the other. There is no detail, yet the form and character of the roses is conveyed. But to achieve that, it was absolutely crucial that the shapes were just right.

Spring Madness
watercolour on Saunders Waterford 300gsm
(140lb) Rough
32 x 46cm (12½ x 18in)

Essentially this painting is about positive
shapes – dark against light.

Effective colour

I regard myself as a colourist rather than a tonalist or an atmospheric painter. For me, colour is crucial. It is all the more crucial because, as I have explained, I am not interested in texture and detail in my paintings. Instead, I concentrate on shape, strong contrasts of light and dark, and colour. Because these are the only three things in my painting 'armoury', I need to exaggerate each of them. With shape, I try to make the contour and shape as dramatic as possible; with light and dark, I make sure I use the lightest light against the deepest black; and with colour, I enhance and change the colour all the time.

People sometimes ask how I see such vibrant and varied colours in the subjects that I paint, because obviously most subjects aren't nearly as colourful as they appear in my paintings. Colour is the main quality that will attract me to a subject, and it is always important that there is the potential to exploit colours. This may involve a certain amount of imagination and exaggeration, but it is usually based on fact. As I look at each colour in a subject, I instinctively register its relative warmth or coolness. Then, if it is a warm colour, for example, I consider which particular colour temperature it relates to – a red, a crimson, an orange, and so on – and proceed to exaggerate it.

I started to emphasize colour in my watercolours quite early on in my career. I became aware that my work, although competent, wasn't competing strongly enough with the more vibrant oils and acrylics displayed around it in exhibitions. I decided that if I made the colour and the tonal contrasts as dramatic as possible, it would give my work the same visual impact that could be achieved in other media. I have kept to that approach: I see no reason why watercolours shouldn't be as colourful and as visually exciting as any other types of painting.

Pecking Order (left) is a good example of this approach. There is always immense potential for exploiting colour when painting hens. Also, they have interesting, distinctive silhouettes and you can have lots of fun using calligraphic brushstrokes for the tail feathers, adding the surprising shadow colours that can be seen in the whites, and so on. I initially sketched these hens at a friend's house, and in fact most of them were black. So I have allowed my imagination a lot of freedom here!

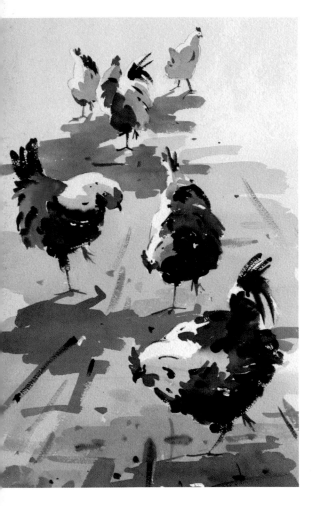

Pecking Order
watercolour on Arches 300gsm (140lb) Rough
46 x 32cm (18 x 12½in)

Hens are a great subject to paint. I love their shapes and the fact that you can really go to town on the use of colour.

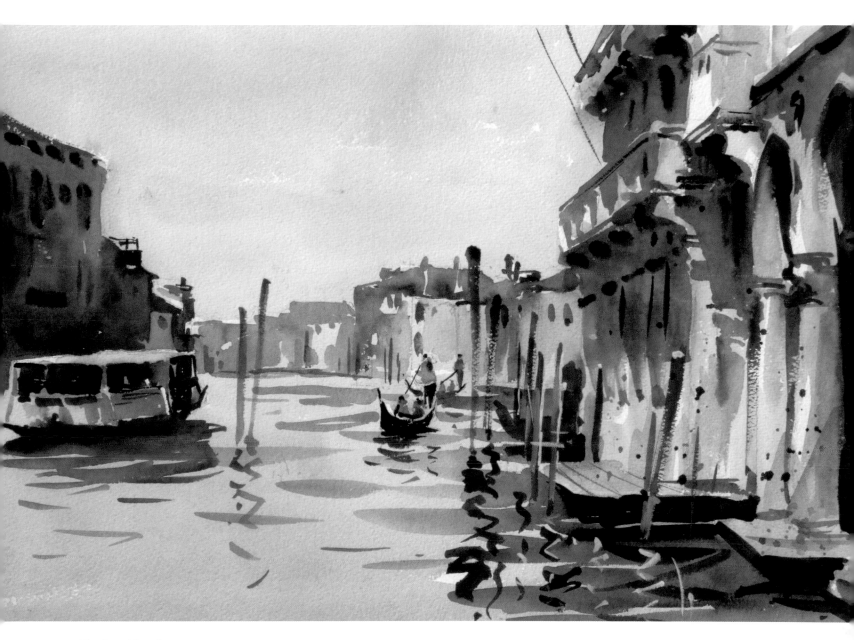

The Grand Canal
watercolour on Arches 300gsm (140lb) Rough
32 x 46cm (12½ x 18in)

Gradually, with experience, the choice and use of
colour becomes an instinctive thing. The impact of
this painting relies on the use of warm against
cool complementary colours – yellow and raw
sienna against violet and purple.

A limited palette

Working with a limited colour palette (keeping to just a few colours that are appropriate for the subject and interpretation) can be an advantage sometimes, particularly if you want to concentrate on tonal properties or create a specific effect of light, mood or atmosphere. I like to have the freedom to use whatever colours I wish, but there are occasions when I find that the subject matter encourages me to work in a more limited way – *Polperro* (above) was an example.

I like subjects that are brightly lit, whether from direct sunlight, strong backlighting or from the side, and I seek out colour. Because my objective in a painting is drama, I need to use bold colour and as much variety as necessary. If I restrict the colour palette, I reduce the drama. For me, the range of colours is only limited by the space in my Craig Young palette.

It is important for me to include one or two bright secondary colours in my palette, such as Winsor violet and Winsor green, which cannot be made by mixing other colours. For example, while I could mix together cobalt blue (my warm blue) and alizarin crimson (my cool red) to make violet, it wouldn't be nearly as bright as Winsor violet from a tube. I can mix most of the earth colours from my palette of primary and secondary colours. But because I use a lot of raw sienna and sepia, I always have those available. They are what I regard as 'short-cut' colours – they save me time, because I don't have to mix them. See also Paints, page 26.

Polperro
pen and wash on Saunders Waterford 300gsm (140lb) Rough
32 x 46cm (12½ x 18in)

I didn't make a conscious decision to keep to certain colours for this image – it just seemed to work out that way. This painting is made with pen and wash, beginning with the pen (which in fact was a sharpened lolly stick) and black ink, and then adding the colour. This is a good technique for capturing the essence of a subject quickly.

The Guin Brothers
watercolour on Arches 300gsm (140lb) Rough
46 x 32cm (18 x 12½in)

Cool colours seemed to suit this subject, in which (as I normally do) I have kept the background weaker in tone to help focus attention on the main shapes.

3 WHAT SHALL I PAINT?

Some subjects are perhaps more suitable than others for painting in watercolour, although ultimately this amounts to a matter of personal choice. Even so, for me that choice is not so much subject-driven as governed by factors such as lighting, colour and the relationship of shapes.

I think that if you are confident with technique, there is no need to rule out anything as far as subject matter is concerned. There is sometimes an assumption that artists have to feel passionate about everything they paint in order to paint successfully. But in my view that is putting the emphasis in the wrong place. More so than the subject itself, it is the *painting* of a subject that you must feel strongly about. I am not necessarily passionate about horses – but I am passionate about painting horses!

I have mentioned light, and this is always a key factor. For example, something that is essentially a very ordinary, uninteresting subject can take on quite a different character and sense of drama in the right lighting conditions. Conversely, seen in flat lighting, what would normally be an exciting subject might look very dull. It is the way that you perceive a subject that is important, and how this will translate into a painting. This is more significant than the subject matter.

So for me, it is considerations such as lighting and composition that might rule out a subject, rather than a simple dislike of it: the qualities that will make a good painting need to be evident. I like subjects in which there are strong connected shapes, for example. I am not keen on subjects that are fragmented or involve lots of detail, such as intimate garden corners. Similarly, because I like to see recognizable silhouetted shapes, I would not really describe myself as a landscape painter.

Maasai Warrior
watercolour on Arches 300gsm (140lb) Rough
46 x 32cm (18 x 12½in)

This might seem an unusual subject, but with its strong qualities of shape, colour and tone, it is exactly the sort of subject I like. When I went to Africa, I was particularly impressed by the fantastic colours I found there.

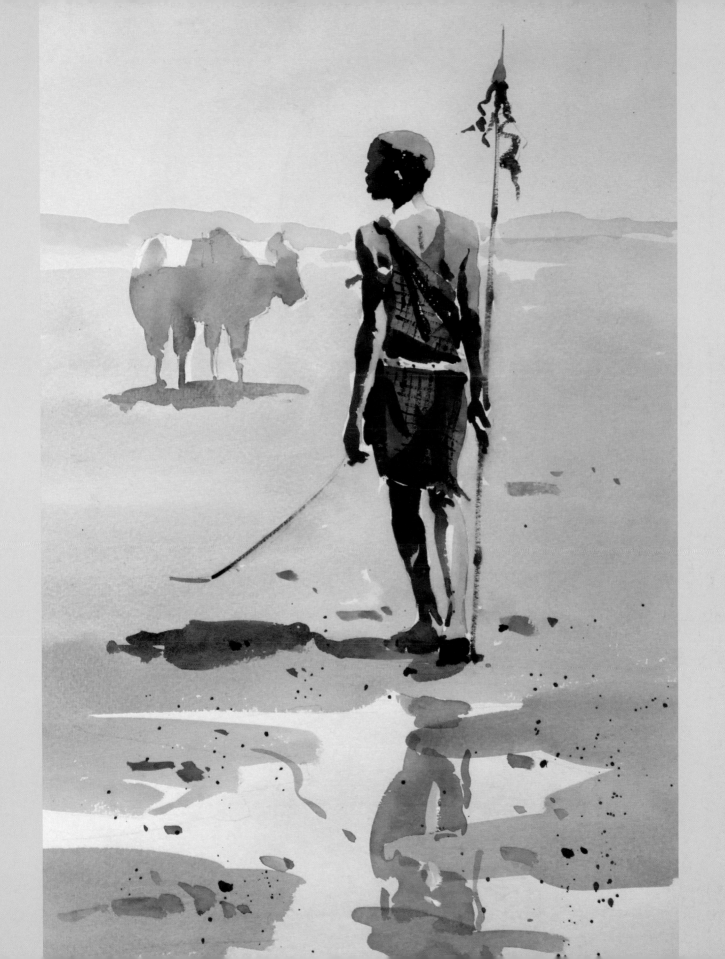

Key considerations

For a subject such as *Nerja, Spain* (opposite), which is essentially a conventional view, it is always sound practice to convey a sense of the far distance. In this painting, it is relatively confined – as far as the three arches. The background colour is cool and, together with the 'lead-in' diagonal lines of the street, this helps to convey a real feeling of depth. Without that sense of depth, it is very difficult to create an interesting composition and thus a convincing painting. You have to imagine a series of layers – the far distance, middle distance and foreground layers – and build the composition with those in mind.

The Portman Hunt
watercolour on Arches 300gsm (140lb) Rough
32 x 46cm (12½ x 18in)

In my vignette paintings I work much more from imagination than from actual reference, but of course a concern for an effective composition and qualities such as light, movement and colour still applies.

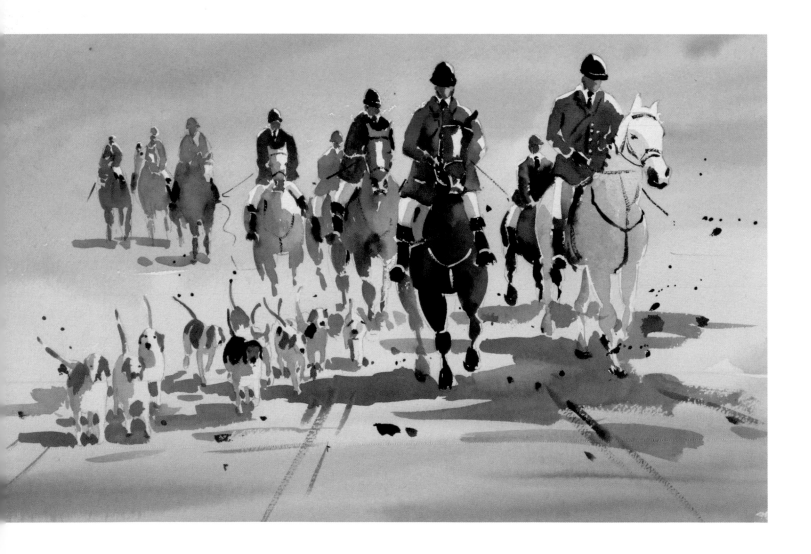

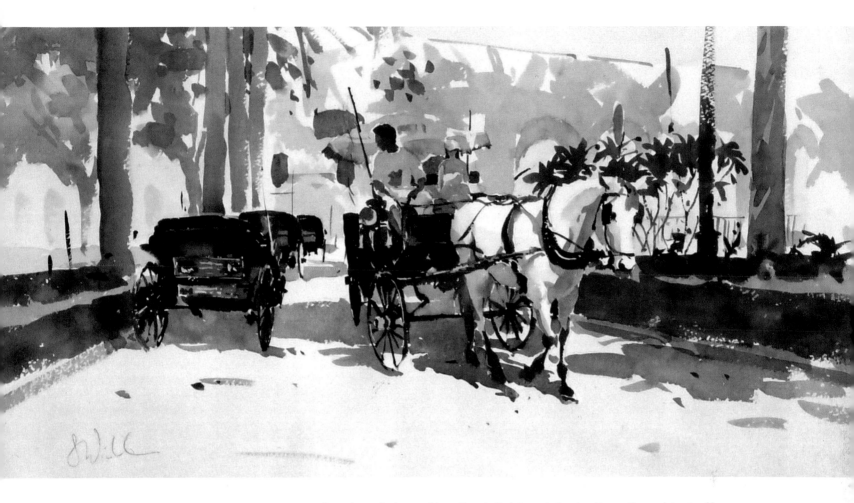

Nerja, Spain
watercolour on Arches 300gsm (140lb) Rough
30 x 50cm (11¾ x 19¾in)

A sense of depth is always a necessary quality in a painting, I think. As here, it can be achieved by using features that lead the eye in (such as the perspective of the street) as well as contrasts of tone, colour and scale.

Another vital consideration is light and shade. Does the subject offer some potential to exploit tonal counterchange? How will the play of light, the contrast between shadow areas and highlights, add to the drama and impact of the painting? For example, the main quality that attracted me to the scene shown in *Nerja, Spain* (above) was the dappled light, giving interesting shadows, yet with the horse in full sunlight. It had some lovely counterchange effects, with the shape of the horse revealed by the dark tones around it – the carriage behind, the hedge to the right, and the foliage above. The subject would not have appealed to me had the light been different, with the horse in shadow.

The Portman Hunt (opposite) is a different type of painting – one of my vignette paintings. I enjoy this approach and in fact it is also a very popular format with the buying public. Although in this painting there are no

background shapes to help convey the idea of depth, there is still a strong sense of depth, achieved mainly through changes of scale and colour, using much cooler colours in the distance.

On site, the best way to record the qualities that make a subject interesting and inspirational is to make a sketch. By all means take plenty of photographs as well – they will give additional information. But, as discussed on page 35, when you take photographs you cannot make that distinction between the qualities that you want to emphasize and the rest of the scene. Photographs give everything an equal importance. For information about key shapes and light and dark areas, in particular, there is no better form of reference than a tonal sketch.

Keep it simple!

In my view, attempting to paint in a photorealistic way and therefore aiming to include every detail is not a wise approach, certainly for the amateur painter. For one thing, it requires an immense amount of skill to do this successfully. But irrespective of the skill, highly detailed paintings are often far less effective – in terms of engaging the viewer, emotive quality and impact – than those in which the artist has used a more personal response involving a degree of simplification.

Pesmes, Franche-Comté
watercolour on Arches 300gsm (140lb) Rough
32 x 46cm (12½ x 18in)

For me, simplification means being true to the subject matter (by not leaving anything out), but concentrating on the essentials of shape, tone and colour. Note the way that I have painted the trees, for example, with broad strokes made with the side of the brush rather than the tip.

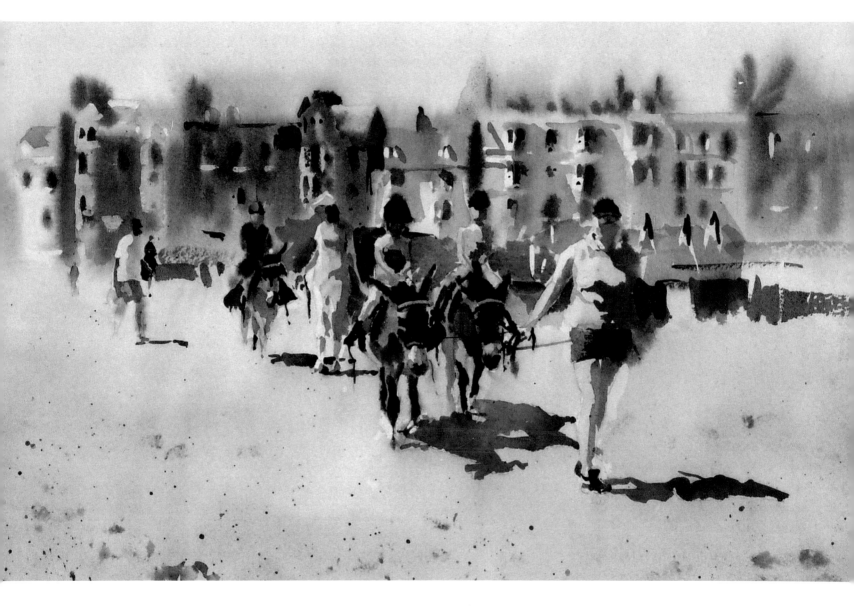

Young Riders, Weymouth
watercolour on Arches 300gsm (140lb) Rough
32 x 46cm (12½ x 18in)

There is a lovely sense of unity in this
painting, created by the wet-into-wet
technique, with most of the shapes fusing
together. The exception is the main figure
in the foreground, which was painted with
more intense colour and a hard edge, and
thus it comes forward and adds to the overall
sense of space.

What do I mean by simplification? In one sense, a painting can be simple and
uncomplicated by virtue of the fact that the subject matter itself is simple.
My vignette paintings are generally of this type. Some artists like to simplify
subject matter by leaving things out – reducing the number of boats in a
harbour, perhaps. But while this might make the content easier to manage,
it often creates as many problems as it solves. What do you put in place of
what you leave out, for example? Also, it is not being true to the subject that
initially inspired you.

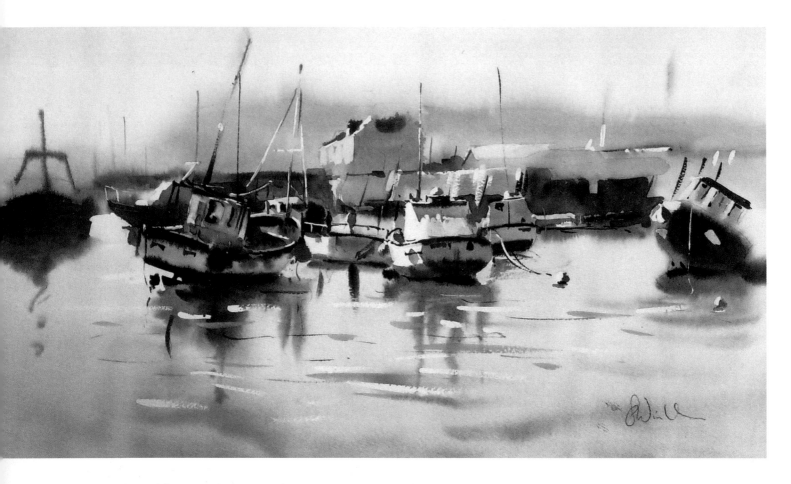

West Bay, Dorset
watercolour on Saunders Waterford 300gsm
(140lb) Rough
32 x 46cm (12½ x 18in)

This complex subject was simplified by
applying the wet-into-wet technique. It
is a technique that requires confidence and
speed. I started by masking the highlights
with masking fluid and then wetting the
whole sheet of paper, building up the painting
over a period of about 30 minutes.

I regard simplification in its truest form as the painting of everything as seen
in a subject, but in a simplified way. I aim to include everything that was
there, but I express it by concentrating on the essentials of shape, colour,
tone, and lost and found edges. I look for shapes rather than objects: shapes
that I can link together, connecting with those of a similar tone. I reduce the
number of shapes from a large number of small shapes to a small number of
large shapes. In this way, the painting gradually develops its own sense of
unity. If, instead, I were to paint one object to completion and then move on
to the next, and so on, the result would most likely be very disjointed.

I might rely on simplifying the shapes, as in *Pesmes, Franche-Comté* (page
60); or I might rely on technique, as in *West Bay, Dorset* (above); or I might
perhaps use a combination of both approaches.

Subjects and inspiration

As I have explained, the desire to paint something is generally motivated by a certain quality or feature within the subject – perhaps an unusual effect of light or colour, or a particular relationship of shapes – rather than the type of subject matter itself. So, don't be deceived into thinking that you must always look for a grand vista to paint – something really impressive and emotive. It is often the smaller, more modest and ordinary subject, caught in the right light or seen from an interesting viewpoint, that will make the better painting. And, whatever the subject, it should be something that you *want* to paint, rather than something that you feel you ought to paint, simply because of what it is or how well it might sell.

Santa Maria Della Salute
watercolour on Arches 300gsm (140lb) Rough
32 x 46cm (12½ x 18in)

Here, again, I have remained faithful to the subject matter; the technique has simplified everything. Having started with the building slightly to the left, under the dome, I worked across to the buildings on the far right, linking together shapes of a similar tone. So, from a series of abstract shapes, a sense of realism gradually emerged.

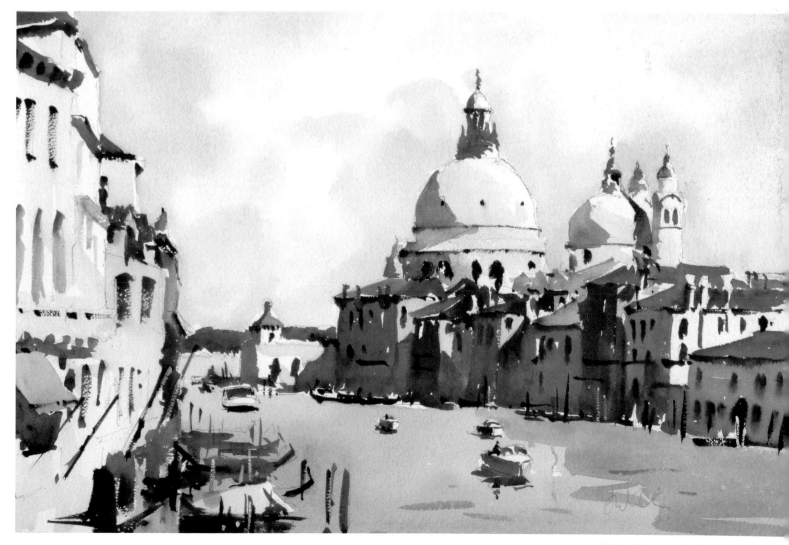

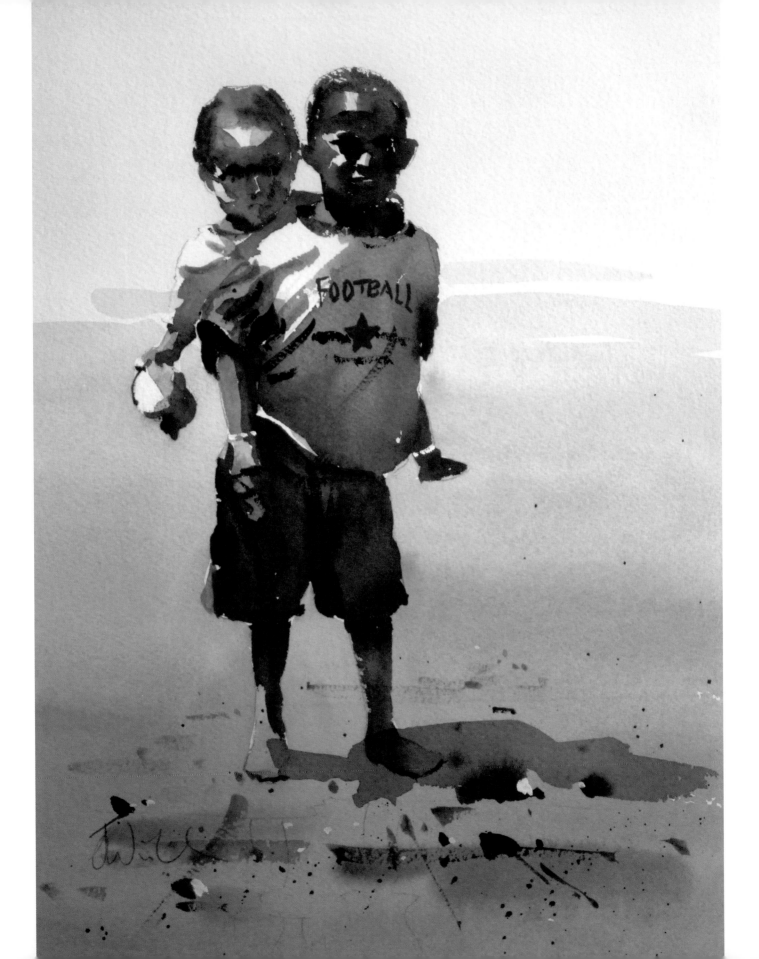

On the Beach
watercolour on Arches 300gsm (140lb) Rough
32 x 46cm (12½ x 18in)

This seems to be a very complex picture, but the effect is all down to technique. The brushstrokes are lively and intuitive, each one quite simple yet conveying a lot of information. Essentially, each figure is formed by his or her silhouette, plus a shadow area within that silhouette. This creates an interlocking pattern of shapes.

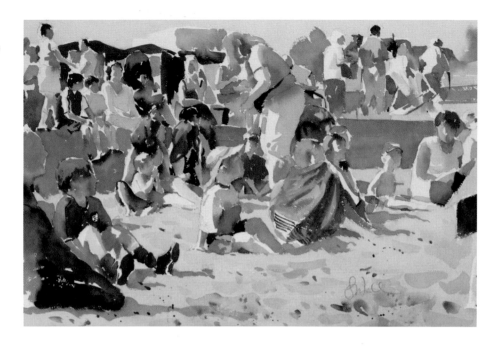

He Ain't Heavy
watercolour on Arches 300gsm (140lb) Rough
35 x 25cm (13¾ x 9¾in)

This was another inspirational subject that I found on my trip to Africa. Light, shade and colour were again the main qualities of interest for me.

Having said that, you may well find certain locations that always prove inspirational. For me, Venice is one such place: it is just meant to be painted, I think. Wherever I look in Venice I am inspired to paint, although again, as in *Santa Maria Della Salute* (page 63), it is essentially the impact of light, shape, colour and tone that appeals to me. In Venice and at other locations I occasionally paint on site, and I am often asked about the advantages and disadvantages of working in that way. In some respects it is more difficult to work outside; in other respects it is easier.

For many artists, one deterrent to working outside is the likelihood of being disturbed by people coming to watch or to ask questions. Sometimes it is possible to find a doorway or a similar place where people cannot look over your shoulder, but ultimately, if you paint in public, the inquisitive passer-by is someone you must get used to. Another difficulty, of course, is the weather and associated conditions, particularly the light, which can change dramatically within a short space of time – meaning that you need to work quickly. Also, unlike when referring to a photograph, there are no fixed boundaries to a subject when you paint outside, so you have to be really focused and decisive about what exactly you want to paint.

But in some ways, those same difficulties and considerations make it easier to paint on site, because you have direct reference to the subject and the actual colours and other qualities that have impressed you. Photographs

have their limitations in this respect, and this is why, whenever possible, I also make a small sketch. However, no one method of working is necessarily better than another, and I am certainly not one of those artists who believes that if a painting is not made from life it is not a work of art.

Observation and experience

For conventional subjects, such as *Edward and La La* (below left) and *Cool Characters* (below right), time spent on observation can lead to a better understanding and response to the subject and, of course, in the subsequent painting it will help you remain true to what you saw and what inspired you. Back in the studio, this experience of the subject, together with information recorded in the form of photographs and sketches, will be key factors in helping you to create a successful painting.

Edward and La La
watercolour on Arches 300gsm (140lb) Rough
35 x 25cm (13¾ x 9¾in)

Light and shade are qualities I look for in every subject. They help create a sense of space and form, and add drama and interest. The lighting inspired me here: particularly with portraits and figures, I find it important to have the subject strongly lit from the side.

Cool Characters
watercolour on Arches 300gsm (140lb) Rough
35 x 25cm (13¾ x 9¾in)

Most of my paintings start with observation – either through direct experience of the subject matter or indirectly, through photographic reference. Essentially my aim is realism, but in an impressionistic style.

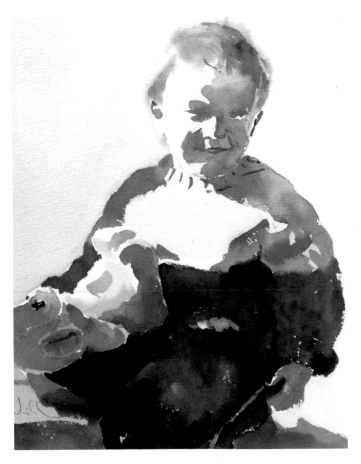

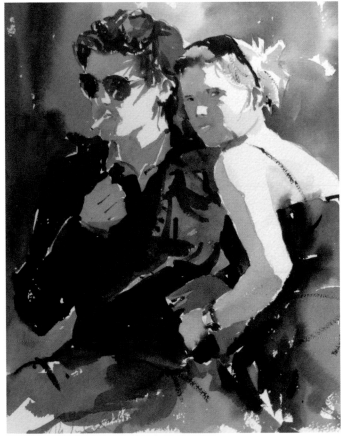

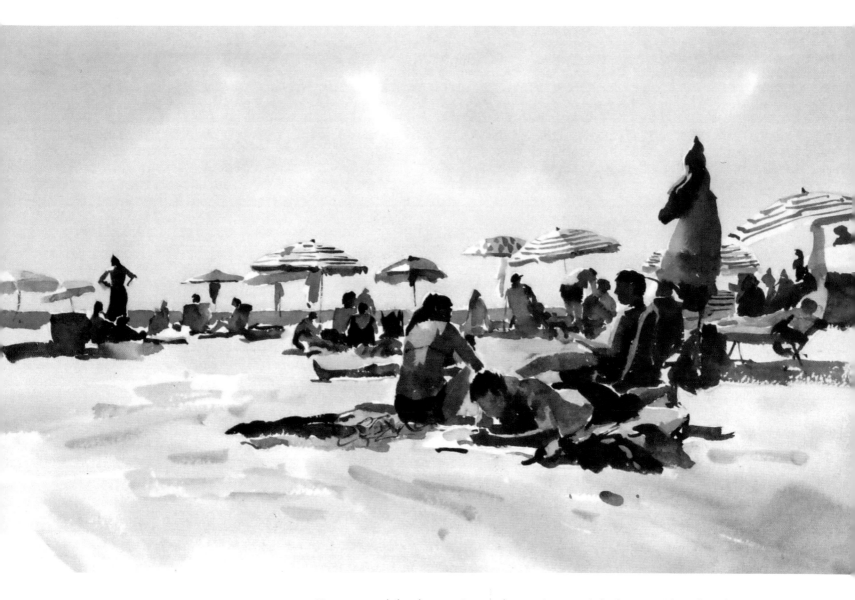

Summer Parasols
watercolour on Arches 300gsm (140lb) Rough
32 x 46cm (12½ x 18in)

Here, I have tried a different type of subject matter from my usual urban, figure and animal subjects. However, the play of light and dark meant that I could adopt my preferred direct, dark-to-light technique.

However, while observation and experience might be considered as the preferred starting point, they are not necessarily essential: other methods can work just as well. I know, for example, that I could have painted *Santa Maria Della Salute* (page 63) without having been there, because for me it is the shapes that are the most important consideration, and I can get that information from a photograph. For the same reason, I don't need to study the anatomy of a horse before I can paint it, because I look for shapes and the way these interrelate to make particular composite shapes and so create the overall image and an interesting composition.

Similarly, observation isn't a vital factor in my vignette paintings. Here, the approach is quite different: I work much more from imagination. Each part has to be just right, but essentially I am inventing the content and shapes to

fit the composition I have in mind. When I paint horses, for example, as in *The Portman Hunt* (page 58), I might refer to photographs and sketches for some of the horses, but others are painted from imagination, and the final composition will be completely my own invention. In the same way, *The Guin Brothers* (page 55) is much more an interpretative painting, rather than one based principally on observation.

New ideas

It is always a good idea to try something new because it helps you to develop a greater breadth of skills and experience, as well as confidence with a wide range of subjects. *Durdle Door, Dorset* (below), for example, was a different subject for me, as I don't normally paint landscapes. Also in this painting, particularly in the sea area, I decided to build up the required effect by using layers of colour, rather than adopting my usual direct approach. Similarly, *Summer Parasols* (page 67), with all the figures on the beach, was an entirely new type of subject.

It is wise to work within your comfort zone to some extent as far as subjects and techniques are concerned, although at the same time there must be a degree of challenge. This will keep your work lively and aid its development – otherwise there is a danger that it may become rather staid and predictable. Ideally, you should be striving for your own identity as an artist, so that whatever subject you choose, it should be recognizable as having been painted by you. A coherent style of your own is what buyers like to see. Once you have a technique that works for you, it should be possible to apply this successfully to a wide variety of painting subjects and situations.

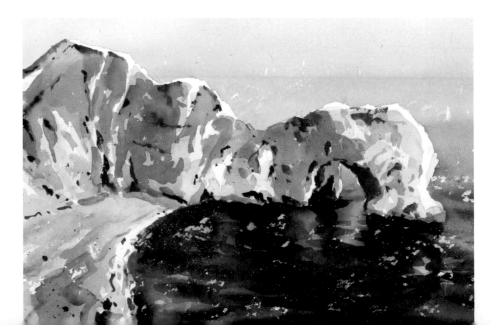

Durdle Door, Dorset
watercolour on Saunders Waterford 300gsm (140lb) Rough
32 x 46cm (12½ x 18in)

I don't often paint in the traditional way, building up effects with layered washes of colour. But I felt that this technique would work well for the sea area in this painting.

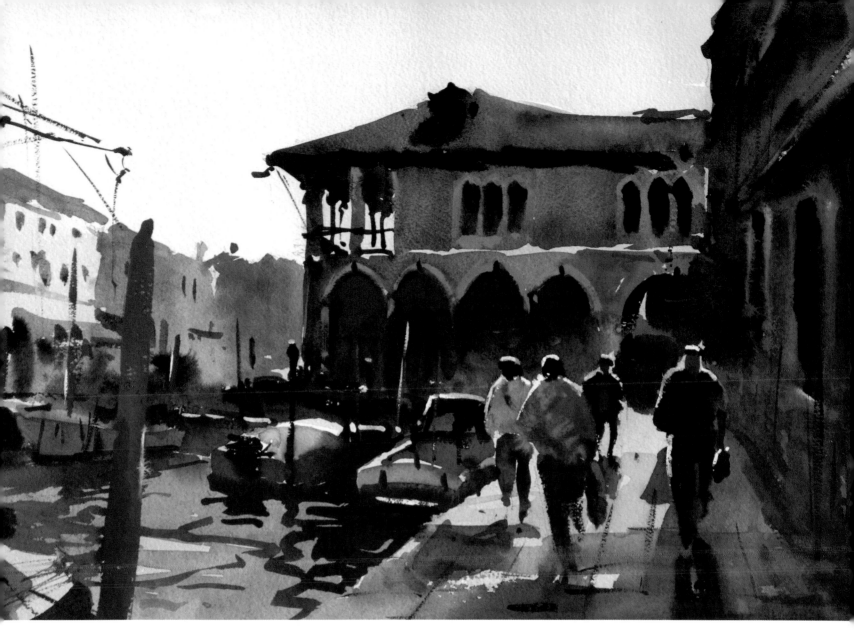

Fish Market, Venice
watercolour on Arches 300gsm (140lb) Rough
32 x 46cm (12½ x 18in)

With this subject, the attraction was the
fact that most of it was in shadow. This
added a greater sense of drama and mood,
which encouraged me to work in a more
spontaneous way than usual.

A way of seeing
Initially, as well as gaining some confidence with the basic watercolour
techniques, it is important to learn how to look at subjects and notice the
way in which they are formed from a particular arrangement of shapes. To
begin with, the tendency is to see objects rather than shapes, so you have to
learn a different way of looking and understanding. Another point about
focusing on objects is that we are more likely to make assumptions based on
what we know about an object, rather than concentrating on what we can
actually see.

So, it is essential to paint what you see rather than what you know, and to develop a painting in terms of shapes rather than objects. With a tree, for example, ignore the fact that it is a tree and look at its shape and the main shapes within that. What tones are those shapes? Are they dark, mid-tone or light? How do those shapes connect with others of a similar tone? Develop the painting in this way, by relating one shape to another, one tone to another, and so on. Look for the important shapes, because this is what will ensure a sense of energy, interest and coherence in the painting.

Interest and impact

A successful painting will hold the attention of the viewer and it can achieve this in various ways, although usually content, colour, composition and contrast will each play a part.

In *Yellow Tablecloth* (opposite), for example, the impact is achieved mainly through the use of counterchange – through contrasts of scale and light and dark. You might expect the large figure in the foreground to dominate the painting, but it doesn't. This is because I have kept it very light in colour and weak in tone – almost ghost-like, in fact. So the eye travels beyond it, to the yellow tablecloth and the man reading the newspaper. Also note that the foreground in general has been completely underplayed, with everything on the table out of focus, which again encourages the viewer to look further into the painting. Similarly, the distant buildings are treated in quite an abstract way, concentrating on the lights and darks and so reinforcing the means of directing the viewer's attention to the middle ground.

Roses on a Mirror
watercolour on Arches 300gsm (140lb) Rough
32 x 46cm (12½ x 18in)

I always work from dark to light with flowers. The dark leaves go in first and it is essentially the counterchange effect – light against dark – that shapes and suggests the flowers.

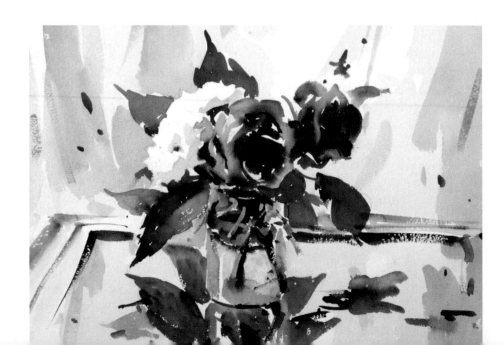

Yellow Tablecloth
watercolour on Arches 300gsm (140lb) Rough
25 x 25cm (9¾ x 9¾in)

As you can see, this painting is essentially just a series of connected shapes. There is no real detail, yet it is entirely convincing in conveying the feeling of a busy street scene, with fine buildings as a backdrop.

I now love painting flowers, such as *Roses on a Mirror* (opposite). But I used to dread painting them until I realized that it is not the subject that is the most important consideration, but the technique. Once I had mastered the technique of linking shapes together, I felt confident that I could paint almost anything. In fact, roses are very delicate and complex, and if you try to show every petal and fold, the flowers can soon start to look overworked and unconvincing. So the best approach is to try to capture the essence of the rose, rather than aiming for a botanical study. And, as you can see in this painting, I have again relied on counterchange – light shapes against dark and dark shapes against light – to help suggest the flower shapes.

4 CAPTURING LIGHT

It is usually a particular effect of the light that adds interest and drama to a subject and so enhances its appeal. Light is often the real inspiration for a painting: essentially, many artists are painters of light.

When I am choosing a subject, the effect of the light is crucial, although for a slightly different reason. I do not paint the subtleties of atmosphere and mood: I like colour. But because I like colour combined with strong tonal contrasts, I need a strong quality of light – preferably bright sunlight, which will add the drama of counterchange with light and shade. So, while light is seldom the main reason why I paint something, it is always an influential factor in my choice. If I go out on a dull day, I can sometimes find a subject that involves interesting reflections rather than a strong light effect, but I would rather have both.

As in *The Shambles, York* (opposite), another advantage of a strong light source is that it creates interesting cast shadows, which can be used to advantage in the composition. Here, the shadows also play an important part in revealing the form and contours of the buildings.

The Shambles, York
watercolour on Arches 300gsm (140lb) Rough
46 x 32cm (18 x 12½in)

With its lovely contrast of light and dark, including some interesting cast shadows, this subject made a very pleasing composition.

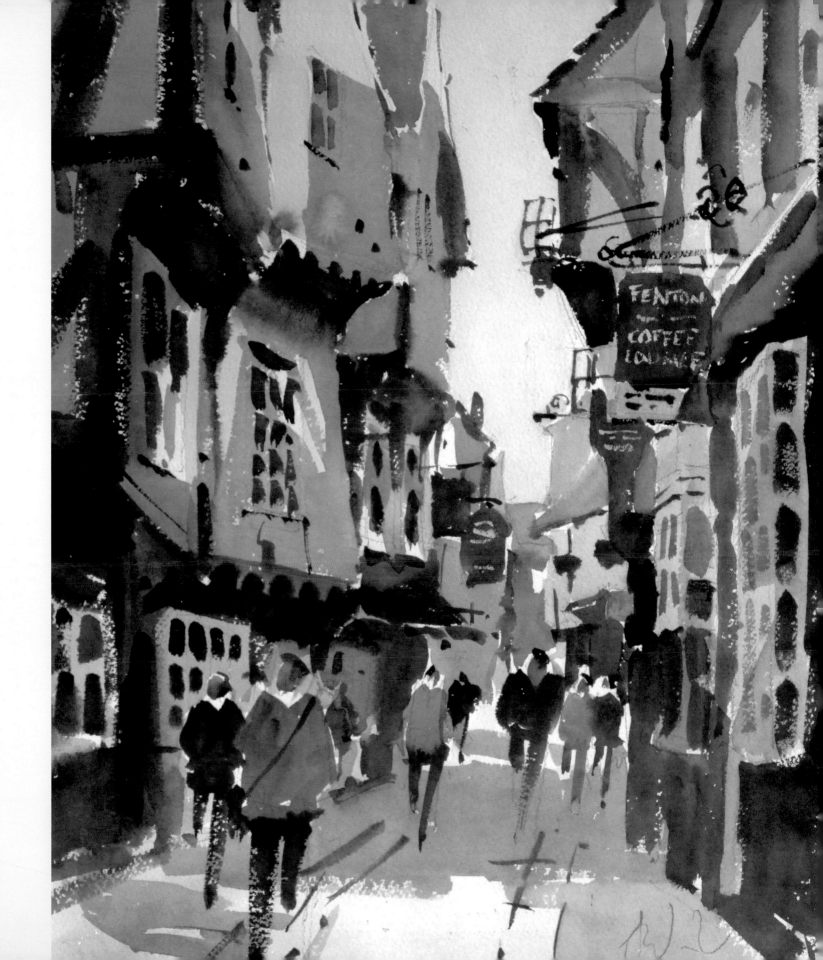

Light and mood

As I have said, my perfect day is a sunny day. Ideally, I look for a subject that is lit by a strong light that is slightly behind and to the side – there are likely to be just as many shadow areas as lit areas. The shadow areas will help to define shapes – the buildings, boats or whatever; the lit areas will mainly relate to spaces – the negative shapes. The fewer the lit/space shapes, the more important it is to place and paint them accurately.

I never find dull days very inspirational, but if I am near water and the light is milky and hazy, I will probably be able to make use of reflections to create the necessary sense of pattern in a painting. But with no reflections or shadows, it becomes a real struggle for me to make the subject work as a painting, because I am only left with the silhouettes of the objects. With bright light, I have both the silhouettes and cast shadows, which gives me many more shapes to work with. Another advantage of a bright day is that I can take good photographs – images that will capture the strong light and shade contrasts in the subject and which will make good reference material. On more atmospheric days, photographs are far less reliable as a source of reference: the best approach in this eventuality is to make a sketch or paint *en plein air*.

Milky Light, Exmouth
watercolour on Saunders Waterford 300gsm
(140lb) Rough
32 x 46cm (12½ x 18in)

Working on location, on a misty day,
I chose a wet-into-wet process for this
subject to capture its mostly soft-edged,
atmospheric quality.

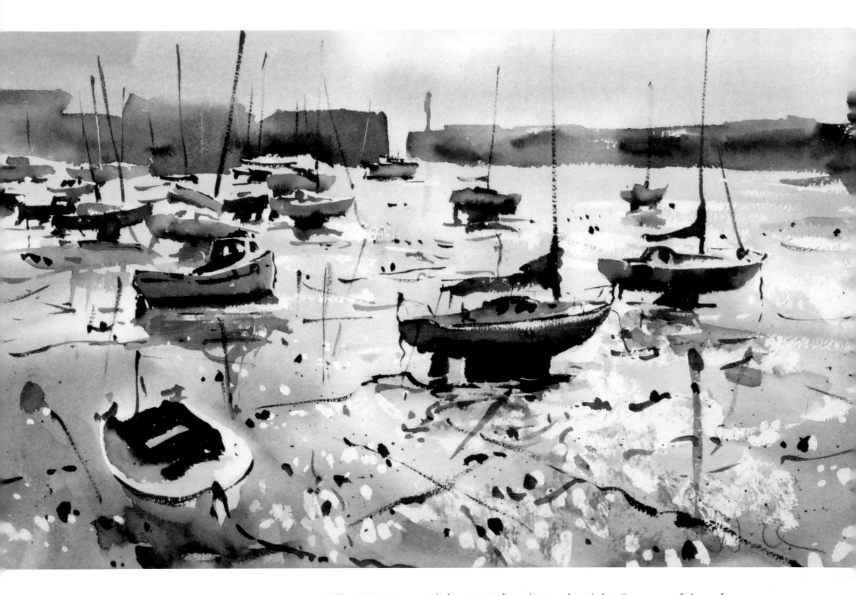

Into the Light, Penzance
watercolour on Arches 300gsm (140lb) Rough
32 x 46cm (12½ x 18in)

This *contre-jour* ('against the light') subject
had lots of strong shapes to consider, and
reflections too. Note that most of the boats
are suggested with just two shapes – a
shadow shape and a sunlit shape.

Milky Light, Exmouth (opposite) and *Into the Light, Penzance* (above)
demonstrate contrasting techniques for painting softly lit and brightly lit
subjects. For the dull lighting conditions in *Milky Light, Exmouth*, which was
painted on location, I chose a wet-into-wet technique, so that most of the
subject was soft-edged in order to convey the semi-misty conditions. I also
wanted to make the most of the reflected shapes, which were more distinct
and hard-edged. In contrast, *Into the Light, Penzance* was a backlit subject in
very strong sunlight and, consequently, there were many more shapes as
well as reflections. For this, I used my preferred dark-to-light technique,
exploiting counterchange.

Interpreting light

I like to be true to a subject, and essentially the composition of my paintings reflects what I initially observed at the scene. However, I do use some interpretation, in the sense that when I am working with colour and tone it usually involves a certain amount of simplification and exaggeration. This is because I want to achieve a satisfactory flow of colour and tonal values throughout the painting, and also these are the qualities that will add extra drama and impact to the result.

There is a huge range of tonal variations from white to black. In some subjects, there could be perhaps as many as 100 different tones. It would be impossible to capture all of these in a painting, and in fact unwise to attempt it, because the painting would become very fragmented. A simplified approach tends to work best.

Snow in Blandford
watercolour on Arches 300gsm (140lb) Rough
32 x 46cm (12½ x 18in)

This is the kind of subject that I really like! In the low winter light, all the buildings on the right were in shadow apart from their roofs, which meant I could treat them as one continuous variegated wash.

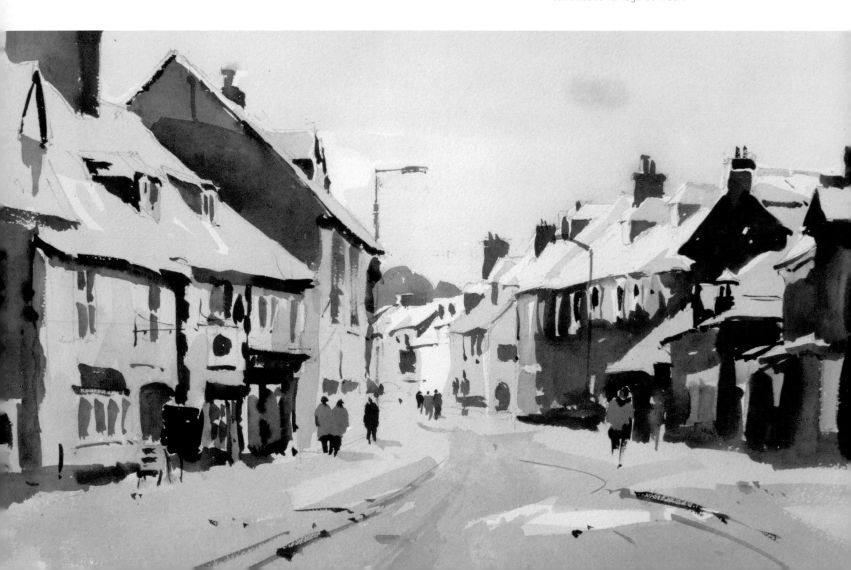

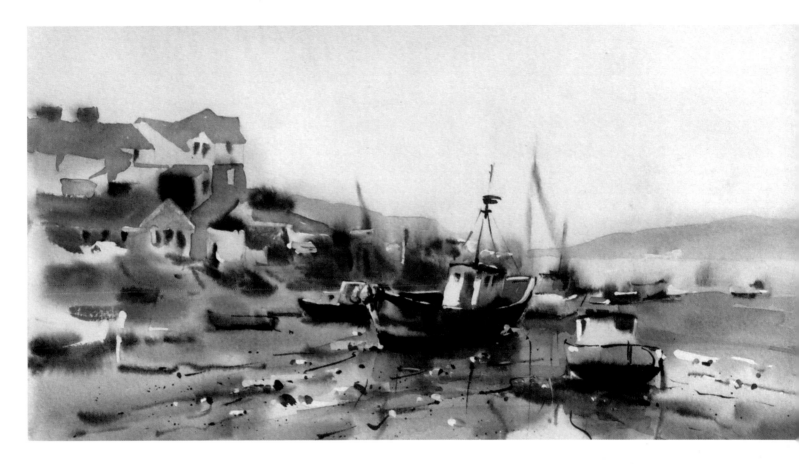

Exmouth Old Harbour
watercolour on Arches 300gsm (140lb) Rough
32 x 46cm (12½ x 18in)

This is a studio painting made from reference
material collected on a trip to Exmouth, when
I also painted *Milky Light, Exmouth* (page 74).
The weather was dull and misty, lacking the
play of light and shade that I prefer, but
nevertheless interesting and particularly
suitable for wet-into-wet techniques.

In my work I aim to include tonal variations as broad groups of tones– see,
for example, *Into the Light, Penzance* (page 75). So anything that is very dark,
towards the black end of the tonal scale, is regarded as black. Similarly,
there will be other groups clustered around dark grey, mid-grey, light grey
and white. As explained on page 17, if you half-close your eyes, you will see
tone in this simplified way. The representation of tone in this fashion will add
to the overall unity, sense and success of a painting.

When painting outside, there can be added problems when you want to
capture a particular effect of the light. The sun moves round and this will
change the position and intensity of the shadows. Success usually relies on
painting quickly, making a decision about the effect of the light that you
want to capture, and keeping to that decision. In most of my paintings, all
the dark areas are painted within the first 10–15 minutes. Consequently, the
light does not change much. But problems can arise with any cast shadows
that need to be added later – a shadow on someone's clothing, for example,
or one that falls across part of a building. Sometimes these are added as an

additional layer of colour towards the end of a painting, when the light may have changed. Then, I have to decide whether to accept how they look at that moment, if that will work with the rest of the painting, or whether to paint them as they were when I began the painting, before the light changed to any great degree.

Tonal contrasts

For any form of representational painting, the ability to judge tonal values correctly is an important skill. Tone is the relative lightness or darkness of a colour and it is the correct interpretation of tone that helps to create the impression of substance, form, space and distance in a painting. Some colours are naturally lighter than others – lemon yellow is a much lighter colour than burnt umber, for example – but equally individual colours can vary in their tonal strength, depending on how much the colour has been diluted during the mixing stage. Often, the tonal values of bright colours are more difficult to judge than those of darker colours. When I do tonal exercises at the classes and workshops I run, I have noticed that most students assess bright yellow, for example, as quite a dark tone, whereas in fact it is so pale that it is almost white.

There are several aids that are easy to make and which are very useful in helping to assess tonal values. One of these is a tonal strip. You can make this from a piece of card about 15cm (6in) long by 2½cm (1in) wide. Divide it into six or seven equal parts (with no white gaps) and, using a soft pencil (3B or 4B), shade in the different sections to create a series of gradated tones from white to black. Hold the strip up to the colour whose tone you want to assess. Half-close your eyes and match the colour to the corresponding tone on the strip.

A useful exercise is to take a colour photograph and, using only Payne's grey watercolour, make a tonal copy of it. My ideal subjects have a lot of shade and not much light, so that the light patches then become very important, as in *Sightseeing* (opposite). Here, most of the figures are in shadow and it is essentially the small areas of light that bring everything to life and add meaning to the subject. But there must not be too many of these areas, or the impact will be lost.

Sightseeing
watercolour on Arches 300gsm (140lb) Rough
35 x 26cm (13¾ x 10¼in)

With the light coming from the right and from the back of the figures, they are mostly in shadow. But notice the importance of the small highlights in revealing more about the shape and character of the figures.

Counterchange

Tonal counterchange is a very effective way of enhancing the impression of light and defining one object against another. This form of counterchange is fundamental to the success of *Taking in the Sights, Andalusia* (below), for example: as you can see, the light upper parts of the horse, the carriage, the man in the white shirt and the umbrella all show up very clearly against the dark trees of the background. In contrast to this light-against-dark counterchange in the top section of the painting, in the lower half the process is reversed, with dark shapes against a light background area.

I use tonal counterchange in most of my paintings. However, for me, the term 'counterchange' has wider implications in the sense of exploiting contrasts and opposites within a painting. For instance, I might also include colour counterchange – warm against cool; or a counterchange of edge – soft edge against hard edge; or exploit contrasts in scale or surface interest – pattern/detail against relatively blank areas/areas of rest.

Taking in the Sights, Andalusia
watercolour on Arches 300gsm (140lb) Rough
32 x 46cm (12½ x 18in)

To me, 'counterchange' means 'opposites', and there are many ways in a painting that these types of contrast can be used to advantage. Here, I have used a counterchange of warm and cool colours, as well as tonal counterchange.

Beagle Pack
watercolour on Arches 300gsm (140lb) Rough
32 x 46cm (12½ x 18in)

Here is a classic use of tonal counterchange.
In the top half of the painting, the shapes are
mostly light against dark; in the bottom
section, dark against light.

Shadows

Because my preference is for subjects that are brightly lit, these inevitably
include shadows of one form or another. As in *Beagle Pack* (above), shadows
tell us about the direction and quality of the light, help to define the form
and contour of objects, add interest, and can contribute significantly to the
success and impact of the composition of a painting. Shadows are always
important: in fact they are just as important as any other part of a painting.

I have noticed, when teaching, that students often find shadows difficult.
There seem to be three main problems: they see shadows as grey; they tend
to underplay the tonal strengths of shadows; and they fail to simplify the
general character of shadows, which results in shadows that are too

complicated, fragmented or patterned and are therefore both unconvincing and ineffective.

Shadows are seldom grey. They mostly fall into the category of warm or cool, but can be absolutely any colour, depending on the light and colour around them. As with so many things in painting, observation is the key to understanding the colour of shadows. If you look carefully at the shadow of a very colourful object, for example, you will probably find that there is a very limited range of colours within that shadow. But with a white object, the shadow could be any colour at all, depending on the reflected light. And even if you think the shadow is grey, avoid Payne's grey! There are lots of exciting warm and cool greys that you can make – mostly by mixing two colours together, such as a primary and a secondary colour. I often use alizarin crimson and Winsor green, for example. You will also find that diluted bright colours will dry to give a greyer hue and so make interesting shadow colours. Look at the colourful shadows that I have used in *Street Busker* (opposite) and also *Bottoms Up* (below).

Street Busker
watercolour on Arches 300gsm (140lb) Rough
35 x 26cm (13¾ x 10¼in)

There are quite often flecks of light within cast shadows, but these are likely to compete with the more important highlights in other parts of a painting and so are best ignored. Therefore, keep cast shadows as full shapes, as I have done here.

Bottoms Up
watercolour on Arches 300gsm (140lb) Rough
32 x 46cm (12½ x 18in)

I like to use as much colour as possible in my paintings, and this applies equally to the shadows. If you make sure that the main colours are intense and dark, the shadows can be any colour. They are seldom just grey!

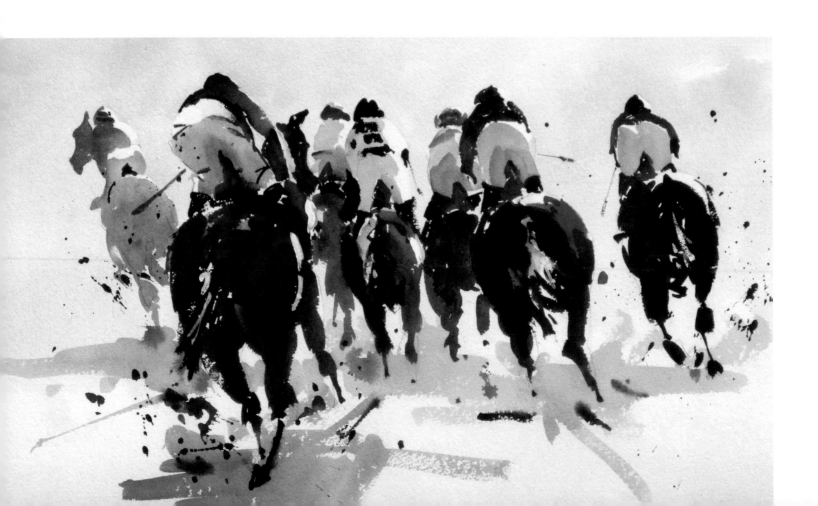

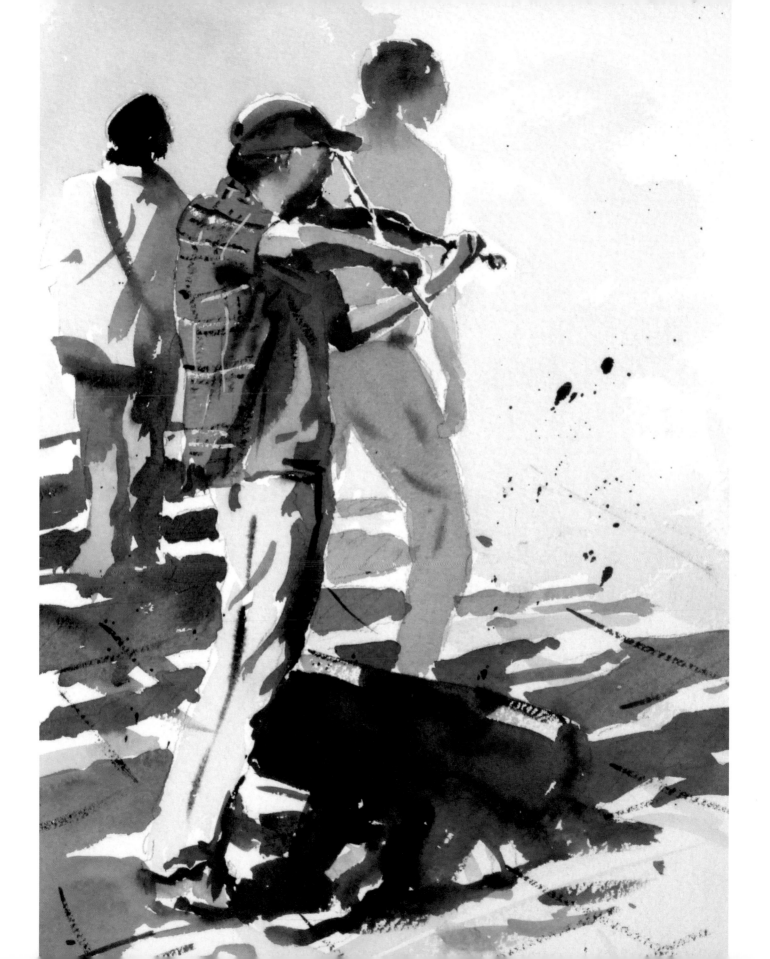

Light, tone and colour

It is vital that light, tone and colour are viewed as a single entity rather than as individual considerations. They are interrelated qualities, which effectively result in the use of particular colours. Each colour must be of the right tone, as defined by a certain effect of the light. Moreover, it is important that throughout the painting process, the whole painting is kept in mind, so that every section fully relates to those around it and to the whole. If there is too much focus on individual parts of a painting, you not only run the risk of including too much detail, but also of making inaccurate decisions about tone and colour. To prevent this, view the subject through half-closed eyes periodically, so that you maintain an overview of the relative tonal qualities.

Shadows in Venice (below) is a good example of this approach. Although I was looking into the light, the buildings in the background were clearly visible – they appeared as quite dark shapes, but I could see every texture and detail. However, when I half-closed my eyes and considered the whole scene, the buildings became much more subservient to the dark shapes in the foreground. They appeared more as a mid-tone in relation to the dark boats in the foreground, which allowed me to simplify them even further and suggest them with a single continuous wash of various colours. When this stage was dry, I added one or two cast shadows, and that was enough

Maasai Farmer
watercolour on Arches 300gsm (140lb) Rough
46 x 32cm (18 x 12½in)

Here, the shadow colours on the Maasai farmer are influenced by reflected light to give a richer version of his own colour and that of his clothing.

Shadows in Venice
watercolour on Arches 300gsm (140lb) Rough
32 x 46cm (12½ x 18in)

Always half-close your eyes to check the comparative light/dark tonal values throughout a subject, so that you can make the most of tonal counterchange in your painting.

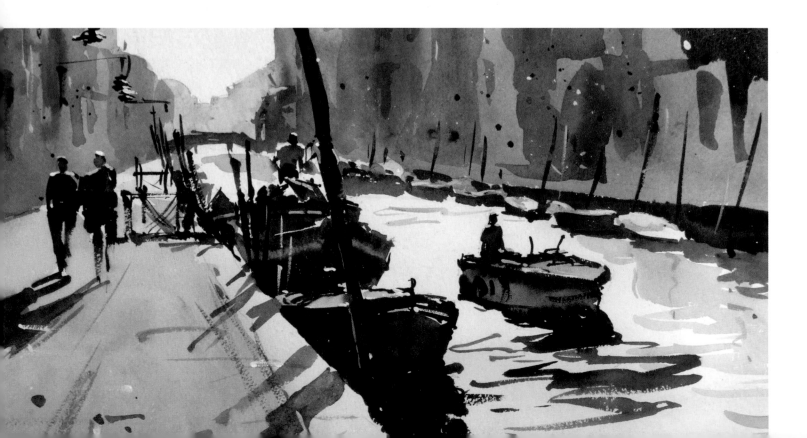

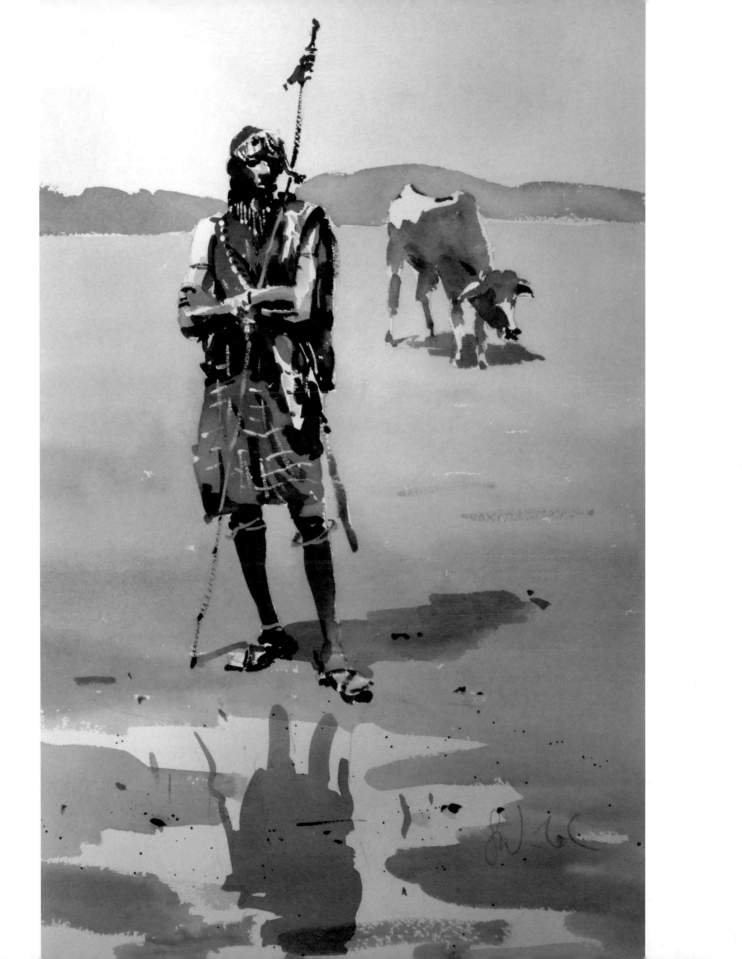

to give the impression of the different buildings. Had I begun with the buildings as dark shapes, which is how I initially saw them, and not considered their relative tonal value within the painting as a whole, the overall contrast of tone would have been much more limited. This would have resulted in a much less interesting and less successful painting.

Colour rhythms

A pattern or flow of related colours throughout a painting is one means of creating a sense of harmony, interest and energy, and it can help as a compositional device. You may like to use a sequence of warm or cool colours, for example, although for me it is the tonal rhythm of the colours that is the most important consideration. Essentially, I look for a rhythm within the dark tones, a visual pathway created by the dark shapes. Because I like dark tones to link in this way, I am much happier with subjects where the background includes some darks, otherwise objects can become isolated within the painting. If there are two separate trees in a landscape, for example, having a dark horizon or hills behind those trees will help link them nicely together.

In conventional watercolours, the darkest and strongest tones are usually in the foreground, with weaker tones suggesting distance. I create a sense of depth by contrasting cool and warm colours. So, although a background colour might be quite dark in tone, it will also be cool in colour temperature,

New England Street
watercolour on Arches 300gsm (140lb) Rough
32 x 46cm (12½ x 18in)

This is a more objective and descriptive approach to colour.

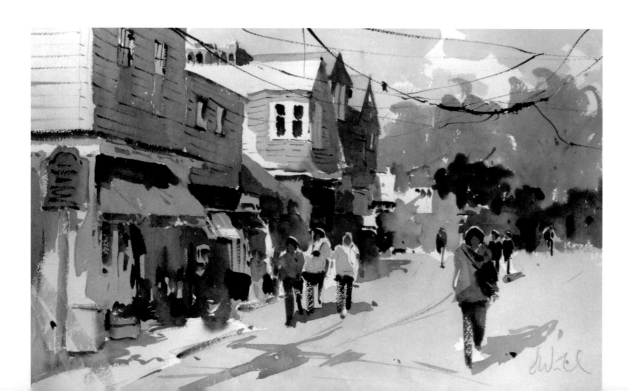

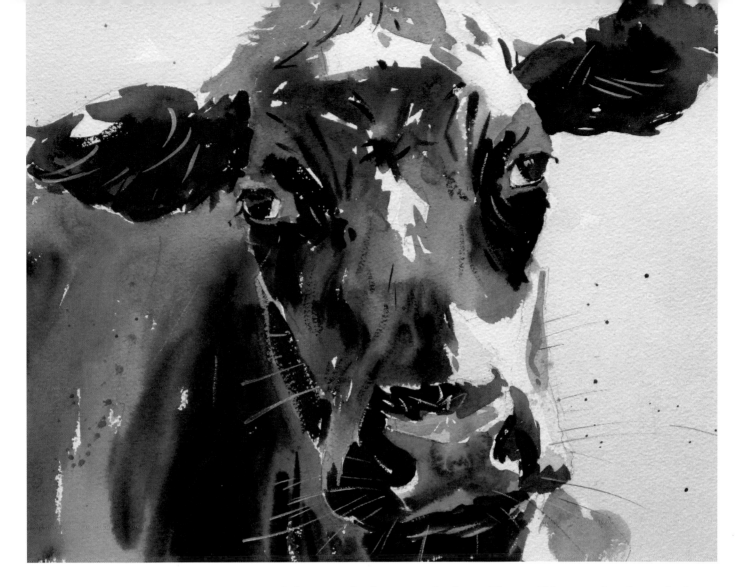

Curious Cow
watercolour on Arches 300gsm (140lb) Rough
35 x 35cm (13¾ x 13¾in)

We know that the cow is black, but it is surprising just how many colours you can see if you really look for the warm and cool variations and exaggerate them slightly.

and vice versa for foreground colours. There will be occasional gaps in these tonal colour pathways, where the eye has to jump to the next dark tone, but I keep these to a minimum, otherwise the painting will lack coherence.

As I have said, I like to be broadly true to the subject in terms of content and colour. The colours I use are influenced by what I see; they are descriptive but also to some extent subjective. I often exaggerate the colours to add interest, as in the case of *Curious Cow* (above), for example. It was basically a black cow, but within the light and dark variations, where I saw a cooler tone I exaggerated it into blue hues, and where I saw warmer tones I used some reds and oranges. In contrast, *New England Street* (opposite) is more objective and descriptive in approach.

5 DRAMA and MOVEMENT

As we have seen, variations of tone can add interest and drama to a painting. Similarly, there are other qualities that can be equally important in this respect, and one of these is creating a sense of movement or energy throughout the work. We tend to think of movement in terms of capturing the feeling of physical movement, as shown in *Wildebeest Stampede* (page 93). But all paintings can involve movement, even when dealing with static subjects such as buildings, landscapes and still lifes. Movement is created by brush technique as much as anything else: lively brushstrokes will add vigour and interest.

Mostly I aim for brisk marks, often holding the brush right at the end of the handle. I want all the marks and shapes to be different, rather than repeating shapes, and therefore my brushstrokes exploit different thicknesses, directions and so on. This adds a feeling of spontaneity, life and energy to the painting. For example, in *Leaping Hares* (opposite), had I painted the hares just in brown, they might well have looked like hares but they would have been static. Because I have used a variety of brushstrokes and colours, with little gaps of white, the sense of movement is greatly enhanced. Also, you will notice that I have avoided painting details. We are not really aware of details when something is moving, and if you include them, it tends to make the subject much more static.

Leaping Hares
watercolour on Arches 300gsm (140lb) Rough
46 x 32cm (18 x 12½in)

To enhance the sense of movement in a subject such as this, I work with a variety of brushstrokes, chopping and changing the colours and leaving a few white gaps. Also note that I keep the detail to a minimum.

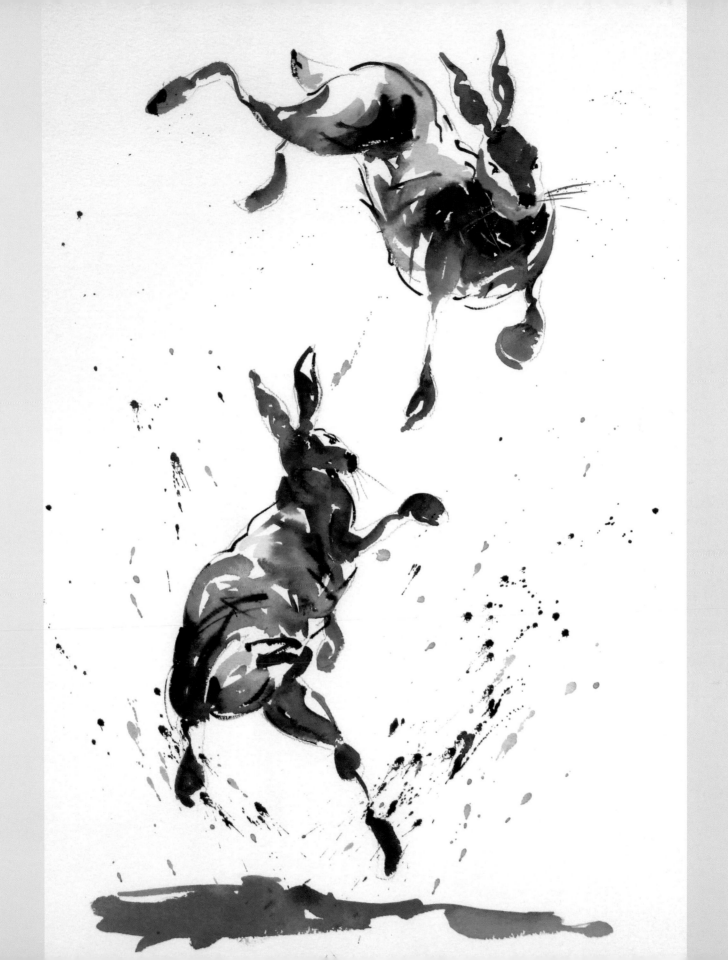

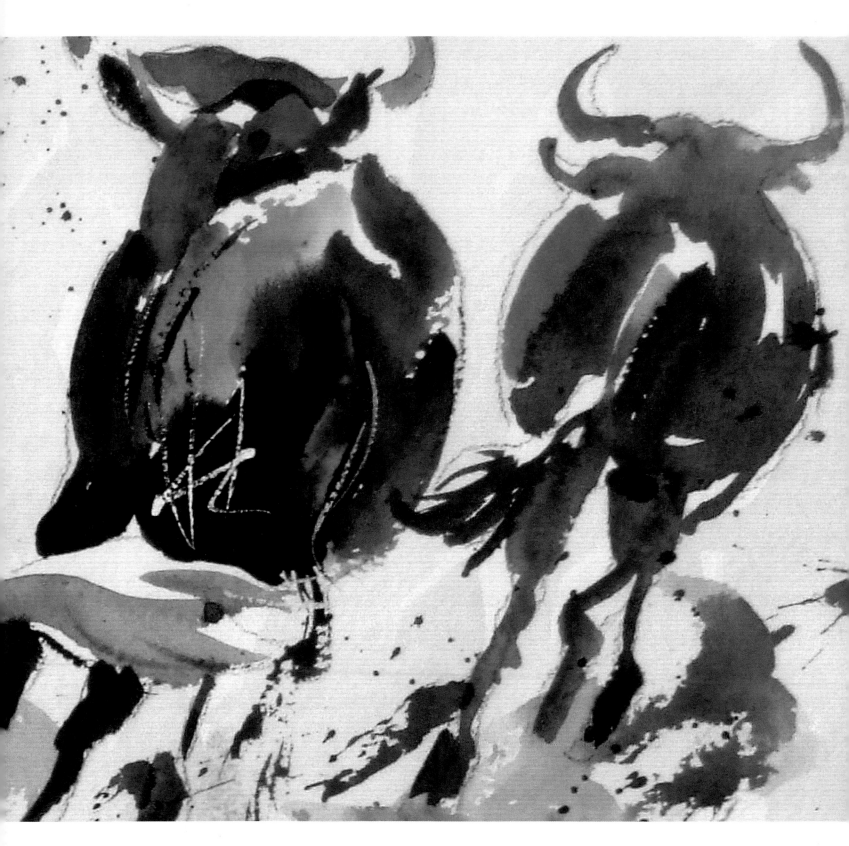

Paint consistency and brush technique

The character of brushmarks, the consistency of the paint and the way it is applied (perhaps as a dry-brush technique, for example, or as a broad sweep of colour made with a large mop brush), and decisions about what to include and what to leave out, are all factors that influence the impression of movement in a painting. These and other points are demonstrated in the details taken from four paintings and illustrated on pages 90–92.

In many of my paintings, the sense of movement or energy in the work results more from my painting technique than it does from a deliberate effort to create a feeling of movement. Because I like to build up effects using tonal counterchange, the play of light and dark creates a movement around the composition and, as shown in *Into the Light, Penzance* (detail below), this can be further enhanced by different directional lines and angles – here the different angles of the masts and the spaces between them. In contrast, in *Wildebeest Stampede* (detail opposite), it was essential to give the impression that the animals were moving quite fast. So I adopted a similar approach to the one that I used for *Leaping Hares* (page 89). I made the brushstrokes and the unpainted spaces follow the direction of each animal's torso and muscles, so that I was interpreting the movement of the animal within its shape. Note that the shadows of the animals are not too specific. If they were, it would anchor the animals to the spot.

Into the Light, Penzance (detail)
watercolour on Arches 300gsm (140lb) Rough

Here, the sense of movement is achieved by the interplay of light and dark shapes, the different angles of the masts, and the variations in the shapes of spaces. For the complete painting, see page 75.

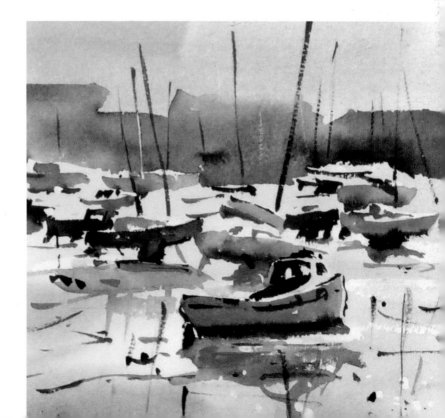

Wildebeest Stampede (detail)
watercolour on Arches 300gsm (140lb) Rough

In sensing the movement of these animals, I worked with brushstrokes that followed their form and, as in *Leaping Hares* (page 89), using a variety of marks rather than just filling in the shape with one colour. The full painting is shown on page 93.

In the detail from *Shadows in Venice* (below right), you can see how I create the impression of figures moving by concentrating on the overall silhouette. The figures have no detail in their faces and no feet: had I included these, they would have attracted attention and so countered any sense of movement. When painting moving figures, make sure that one leg is longer than the other and avoid having both arms held down by the side of the body as it makes the figure look very symmetrical and static. Instead, have one arm crossing the body. Notice that I have used dry brushstrokes for the legs, as this enhances the impression of movement.

The detail from *Sherborne Abbey* (below left) shows how light can be the key factor in adding movement to a painting. The play of light and dark, combined with cool and warm colour washes and a spontaneous technique, creates its own sense of movement, if in a more subtle way than in other paintings.

Sherborne Abbey (detail)
watercolour on Arches 300gsm (140lb) Rough

Contrasts of cool and warm colours, as well as tonal counterchange, add a sense of energy and movement to a painting. See page 98 for the complete painting.

Shadows in Venice (detail)
watercolour on Arches 300gsm (140lb) Rough

With moving figures, it is all about suggestion rather than detail. Concentrate on the silhouette, the overall impression of the figure, and avoid details such as facial features and feet. See page 84 for the complete painting.

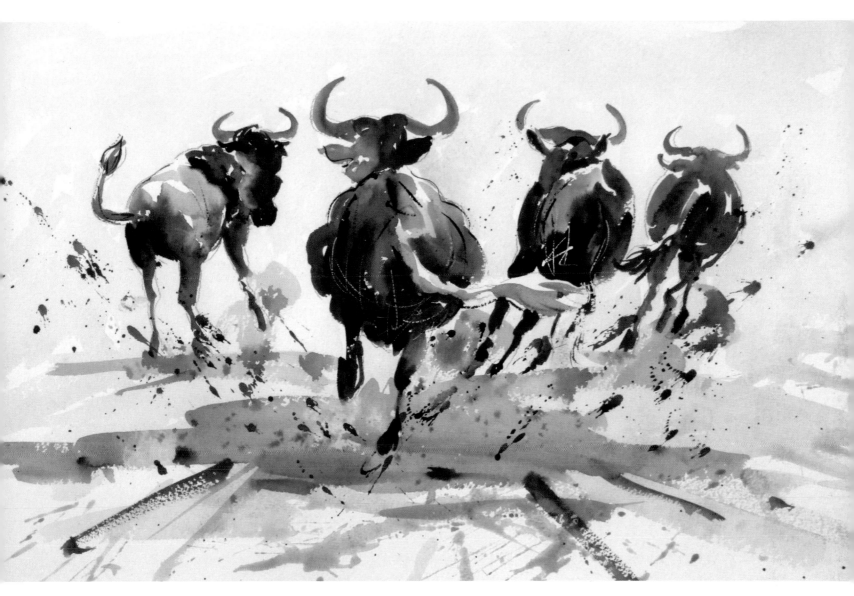

Wildebeest Stampede
watercolour on Arches 300gsm (140lb) Rough
32 x 46cm (12½ x 18in)

Here, I have used all sorts of colours applied
wet-up-to-wet, so that they blend together,
but also combined this with some very
important space shapes. Spattered paint and
directional lines add to the effect of
movement.

Limited washes

I usually work with small amounts of different colours – limited washes – but
adding these quickly to the painting so that they link and fuse together.
I constantly change the colours as I work, to suit the tonal and other effects
that I want. This particularly applied to *Wildebeest Stampede* (above), in
which I wanted to convey a strong feeling of movement. If you look closely
at this painting you will see that I have used all sorts of colours blended
together, combining these with some pertinent space shapes. I started this

painting with a very pale wash of colour for the background. Once that was dry, I began painting the most important animal, the largest one in the centre, dipping into various colours in my palette and concentrating on the animal's shape and form. Notice that I have exaggerated any slight bumps and variations in the silhouette, so that it is not just a smooth curve but something more interesting and lively.

Sometimes, as in *Wildebeest Stampede*, I finish with a rigger brush to enhance the feeling of movement by adding a few lines in black and white. I add these as swift, calligraphic marks, working with the brush in the same way that I would use a pen in a pen-and-wash painting. Also in this painting, I have used a spattering technique and some directional lines in the foreground, which similarly help to capture the sense of power and speed of the stampeding wildebeest. Other factors that contribute to the impression that the animals are moving are the change of scale (the furthest animal is much smaller) and the variation from cool colours to warmer ones – blues and greens in the distance and purples and ochres nearer to us.

Similarly, my use of small blocks of colour applies to paintings in which I work from dark to light involving lost and found edges, as in *Port Isaac* (page 96). Again, this is a technique that relies on speed and linking shapes together. In so doing it creates a subtle sense of movement and energy within the painting.

The Beachcomber
watercolour on Arches 300gsm (140lb) Rough
25 x 35cm (9¾ x 13¾in)

One of the first things to learn about painting is that you must look for shapes rather than specific objects. Notice the linking shapes of light and shade in this subject.

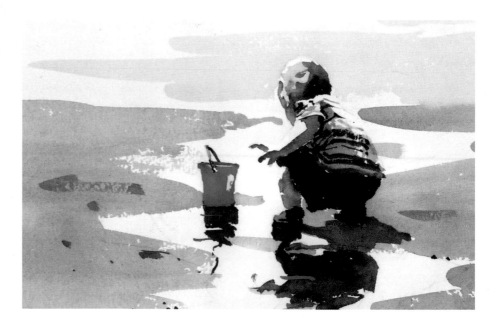

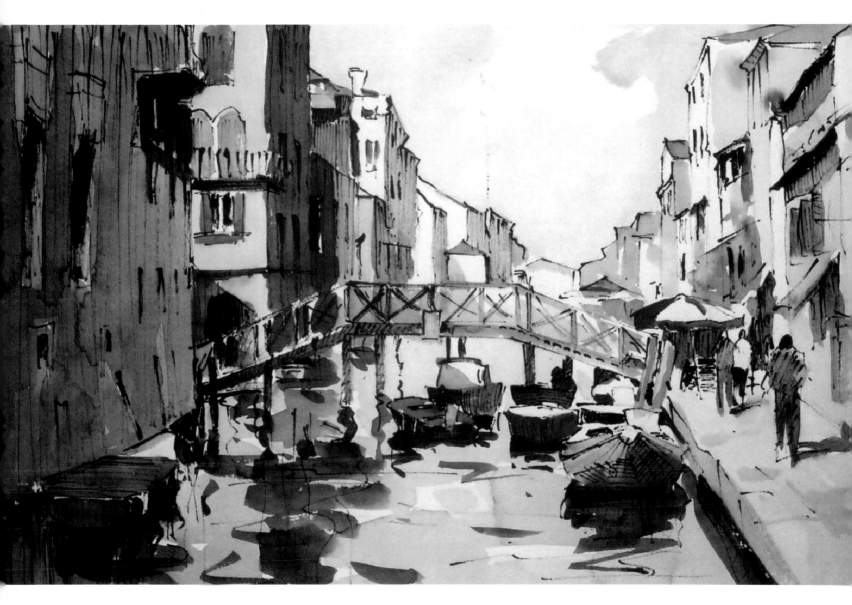

Venice Bridge
watercolour on Arches 300gsm (140lb) Rough
32 x 46cm (12½ x 18in)

This was painted in a very spontaneous way,
using a pen-and-wash technique. I began by
drawing the main shapes in black ink with my
'pen', which in fact was a sharpened lolly
stick. I sharpened it to create a wedge-
shaped end, so that it would give both thin
and thick strokes. I also added some of the
shadow areas in this way, using a hatching
technique. Then I applied the colour washes.

Spontaneity and the direct method

Spontaneity is a vital factor in the way that I work. The alternative to
spontaneity is a planned approach in which all the key decisions relating to
tonal values and other concerns are made right at the start, and then the
painting is developed stage by stage while adhering to those decisions. This
can result in very effective paintings, of course, but it does not suit my direct,
dark-to-light method of working. The direct method relies on linking shapes
together, working quickly and adjusting the tone and paint consistency as

required; part of its impact and appeal is the unplanned sense of spacing. It can only succeed in capturing the essence of a subject with vigour and individuality if the approach is, for the most part, intuitive and spontaneous.

Such an approach might seem daunting at first, because there is no time to ponder over decisions – they have to be made almost instantly. Once you have started and are committed to the painting, there is no going back. As I have stressed earlier, the brushmarks need to be confident: you must have faith in the marks you are making. Possibly some of the marks you make will be less effective than you would like, but within the painting as a whole this may not matter too much. It is the vigour and personality of such paintings that is their strength. While carefully planned paintings are often very sound as far as technique is concerned, they can be very lacklustre in terms of their overall impact and attraction. Direct painting might be more challenging, but in my view it is certainly more rewarding.

Port Isaac
watercolour on Saunders Waterford 300gsm (140lb) Rough
32 x 46cm (12½ x 18in)

Here is an example of how you can convey a feeling of busyness and activity in a painting without putting in every detail – essentially by working with tonal counterchange.

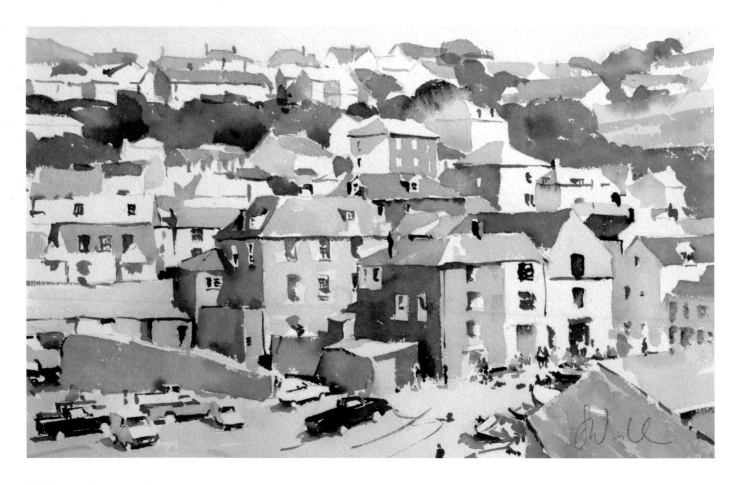

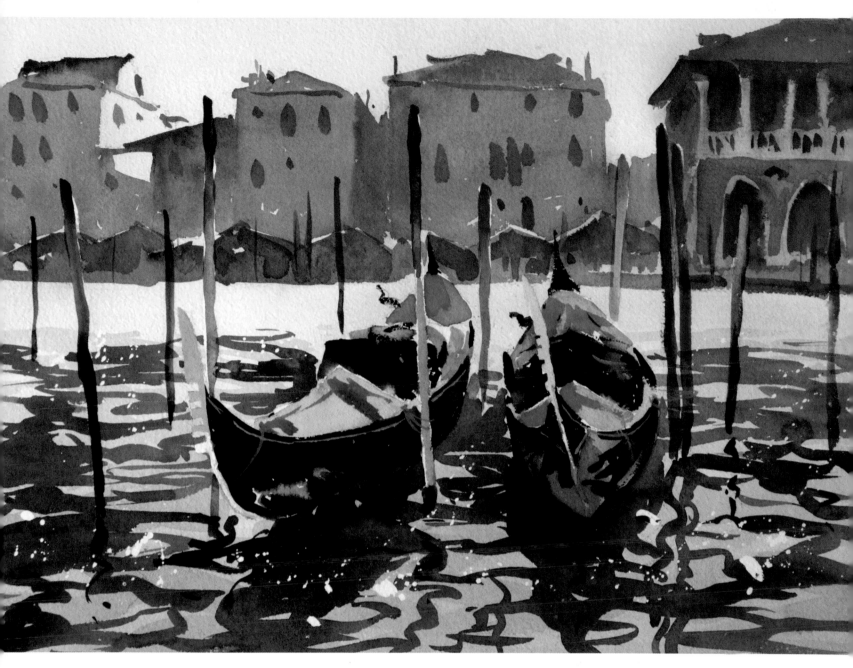

Gondolas Resting
watercolour on Arches 300gsm (140lb) Rough
32 x 46cm (12½ x 18in)

Here again, the success of the painting relied
on creating tonal/colour pathways, and there
is an interesting directional counterchange
between the wobbly horizontal lines of the
ripples and the straight vertical poles.

How much detail?

I like busy subjects. *Port Isaac* (opposite) is a very busy subject. However,
I think you can still convey the feeling of busyness and activity in a subject
without putting in every detail. I don't leave things out, but instead rely on
my technique to capture the content and character of a subject in a more
simplified way. This approach also ensures that the painting has that vital
sense of energy and movement.

In *Port Isaac* (page 96), the overall impression is of lots of buildings, but as you can see, the majority of these are suggested by using tonal counterchange. The eye is drawn to the larger buildings in the foreground, because these are more complete. But as the other buildings recede into the distance, they become a linked pattern of dark and light shapes. Similarly, in the foreground, the cars and figures are expressed in the simplest terms, using dark and light shapes and leaving the details to the viewer's imagination.

Sherborne Abbey
watercolour on Arches 300gsm (140lb) Rough
25 x 35cm (9¾ x 13¾in)
I sometimes use dark tones in a background, but I usually keep the colour temperature cool and the shapes virtually silhouetted, as shown in this painting.

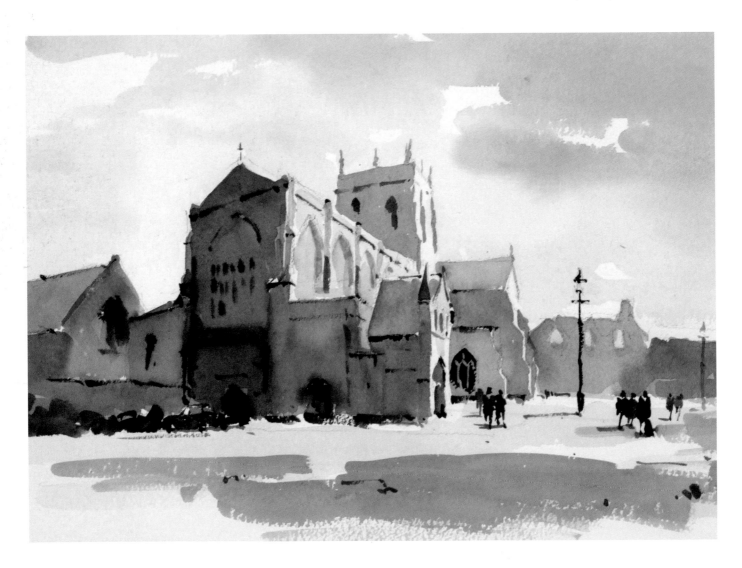

Tarrant Monkton
watercolour on Arches 300gsm (140lb) Rough
32 x 46cm (12½ x 18in)

Usually the main focus of interest in a
painting is the middle-ground area, as here,
with the foreground acting as a supporting,
lead-in area.

Foregrounds and backgrounds

Generally speaking, most of the interest and action in a painting will take
place in the middle ground, with the foreground and background playing a
supporting role. Sometimes you see paintings that are exceptions to this
general rule – perhaps having a detailed foreground as the main element of
the painting, for example, with everything else subdued. But this is rarely
done. Usually the foreground acts as a lead-in to the centre of interest in the
painting, while the background adds the necessary sense of space and
context. It is important to bear in mind that if these areas become
overcomplicated, they will detract from the main part of the painting and
then the full impact of the work will be lost.

In *Tarrant Monkton* (page 99), the focus is the middle distance and so the foreground is shown out of focus and painted wet-into-wet. In fact, if you were standing there, looking at this view, that is how you would see it – the foreground would be in your field of vision but out of focus. Therefore, I didn't want to paint every blade of grass, as this would have conflicted with the focus on the buildings behind, although I did want something happening in the foreground that would carry the eye into the painting. A flat area of grass would not have been very interesting or convincing, so I decided to make the nearest part darker in tone, with just a few brushmarks, and this has helped in creating a lead-in and sense of depth.

The Butt and Oyster
watercolour on Arches 300gsm (140lb) Rough
32 x 46cm (12½ x 18in)

I was really happy with this painting because the particular effect of the light and the composition worked so well. The subject had just the right amount of busyness and tranquility.

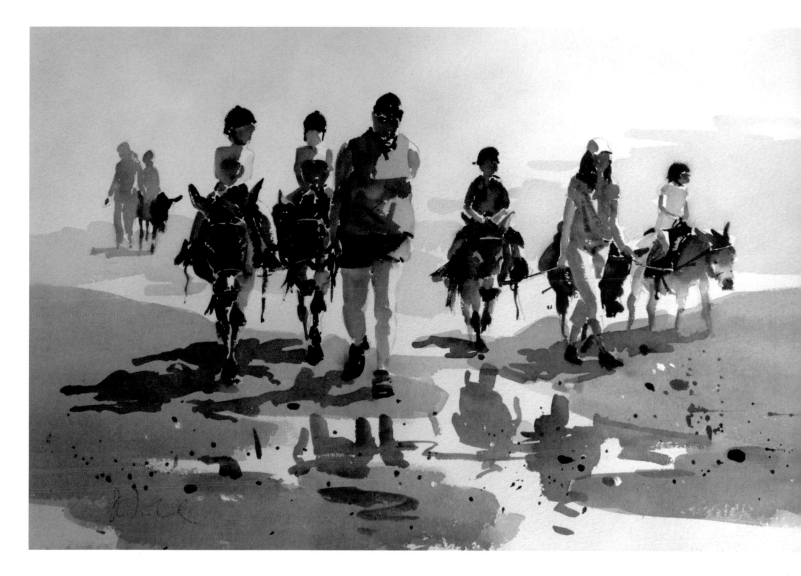

Junior Riders
watercolour on Arches 300gsm (140lb) Rough
32 x 46cm (12½ x 18in)

In this subject-driven painting, the focus is on the donkeys and figures and their reflections; the background is kept very subdued.

The foreground in *Sherborne Abbey* (page 98) shows a similar approach, using just a few bold, sweeping brushstrokes of colour, and also in this painting you can see how I have simplified the background. The distant structures were painted in silhouette, with very cool, thin washes of colour. Note how this is in contrast to the nearest part of the abbey, which is very warm in colour temperature. Notice also the tower, which I added in a mid-tone and painted in a more vaporous way to help convey the building's depth.

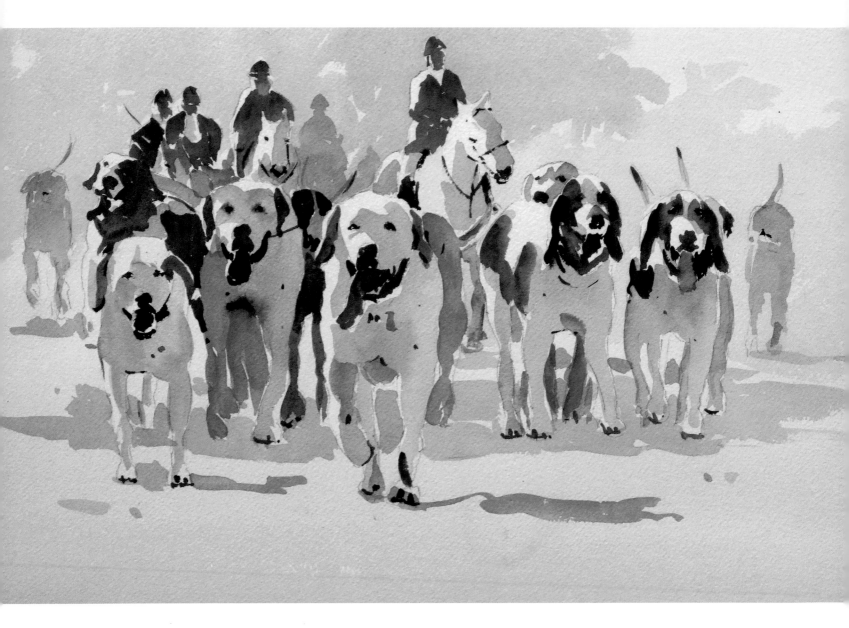

Hounds
watercolour on Arches 300gsm (140lb) Rough
32 x 46cm (12½ x 18in)

In aiming to convey a strong sense of movement, the key elements in
this painting are the composition, the expressive shadow colours, the
important white shapes, and a minimum amount of detail.

Step by step: **From Accademia Bridge**

1 Because I knew that I wanted to include staining colours, such as Winsor green, in the later stages of this painting, I began with the background washes – having first masked out a few highlights with masking fluid. I knew that if I were to add the staining colours over the background once it had dried, the colours would not bleed.

2 Starting with the buildings on the left, I worked in a continuous, spontaneous way to complete all the buildings.

3 **From Accademia Bridge**
watercolour on Arches 300gsm
(140lb) Rough
46 x 32cm (18 x 12½in)

The dark reflections were added last of all, using fairly strong colour made by mixing alizarin crimson and Winsor green.

Content and composition

The composition of a painting – the choice of subject matter from a certain viewpoint, and consequently its arrangement within the picture area – is always a key factor in creating drama and movement. The impact of the composition is also influenced by the relationship of elements such as line, mass, tone and colour. Essentially, a successful composition is one that holds the viewer's attention within the picture area, and usually its form is such that we are directed to a particular point of interest.

For example, *The Butt and Oyster* (page 100) is a painting that I am really pleased with, because I think the composition is just beautiful. It has exactly the right balance of busyness and tranquillity. This is not a contrived composition: I haven't moved things around to improve the painting's impact. For me, the composition is always inherently as seen in the subject. It is one of the considerations when choosing a subject: I paint what is there. What I particularly liked about my view of the Butt and Oyster was the way that everything worked to create a focus on the building. The sunlit white building is emphasized by the tone of the roof, which in turn is revealed by the darker trees behind. Various lead-in lines – the shoreline, the darker area in the foreground on the right, and the distant line of boats – direct us to the building and help create a lovely flowing movement around the painting.

Step by step: Jumble at Pin Mill

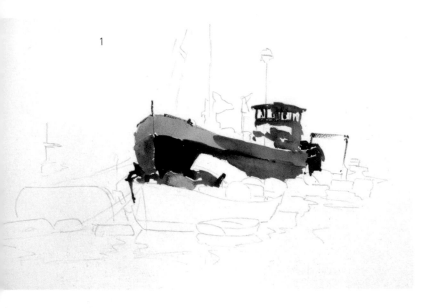

1 I started with the cabin area of the boat, adding shape to shape. I usually start with a small area and then move on to larger shapes.

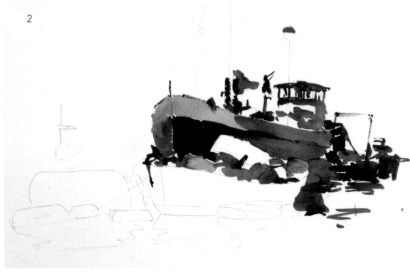

2 I continued developing the entire subject in this way, linking together colours of a similar, or the same, tonal value.

Vignettes

A true vignette is a painting or illustration that fades into the space around it without a definite border. My vignette paintings are based on that principle but usually have some form of background content, although this will be a mere suggestion of a background. In these paintings, the focus is the subject and there is nothing else of any note to divert attention away from that. I like the fact that such paintings are uncluttered; they have a simplicity and directness that is very appealing and which I am happy to say I have found to be equally enjoyed by the buying public.

Junior Riders (page 101) illustrates this approach. I have kept the background very simple, using just three or four broad washes of colour.

3

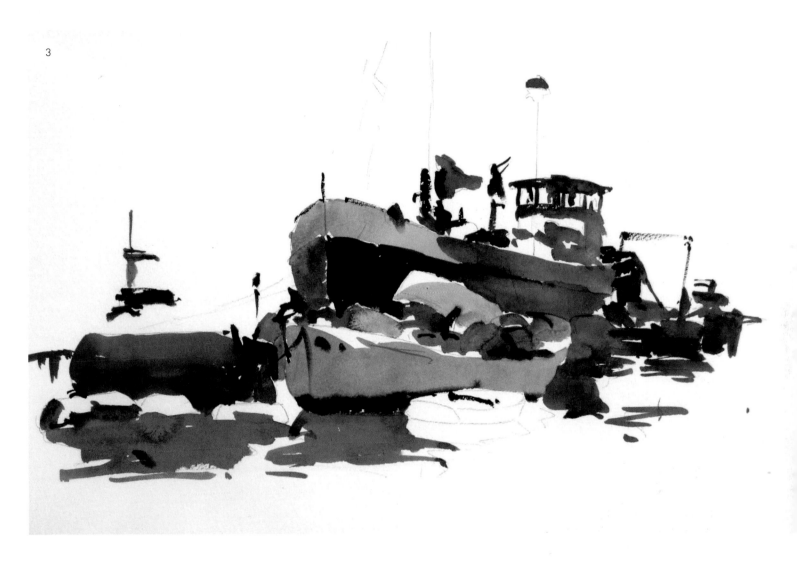

3 Next, I considered the foreground shapes. All the time I am painting what I see, rather than what I know.

Establishing a focal point

In representational painting, the usual practice is to have a composition that is built around a focal point or centre of interest. The focal point might be something significant within the subject matter itself, such as a particular figure or part of a building, or it might be something of a more abstract nature, such as a dominant colour or shape. The focal point is a sort of visual resting place, and there will be various elements within the composition that will lead the eye to that point.

In some of my paintings I include a focal point, but in others I have no particular focal point because I want to encourage the eye to roam around the picture. The focal point can be quite a small area within the painting and, as shown in *From Accademia Bridge* (page 103), it doesn't need to be the strongest colour or tonal contrast. In this painting, the two small domes in the far distance are the focal point, with the perspective of the buildings directing our attention to that point. A pure patch of white water beneath the domes highlights that area, but otherwise there is no emphasis in terms of colour or tone. Street scenes and views like this nearly always converge to a vanishing point/focal point in this way.

In contrast, in *Jumble at Pin Mill* (right), which was painted on location, there is no specific focal point. Partly, this was the appeal of the subject. I thought it was wonderful, because there was such a variety of nautical clutter, making an incredible arrangement of related shapes, with each one of equal interest and value to the next. It is the type of painting that I love doing – not planned, but reliant on technique.

Whatever type of composition you choose, the important thing to bear in mind is to avoid unwanted distractions in the painting. In a sense, a focal point is a distraction, but a wanted distraction. However, if you have a focal point and another area of the painting unintentionally also claims attention, the impact of the painting will be lost. *Jumble at Pin Mill* doesn't have a focal point, but neither does it have any unwanted distractions. Its strength is in the pleasing arrangement of shapes. See also *Shapes and Spaces*, page 47.

Jumble at Pin Mill
watercolour on Arches 300gsm (140lb) Rough
32 x 46cm (12½ x 18in)

Finally, I added the mast and a few details.

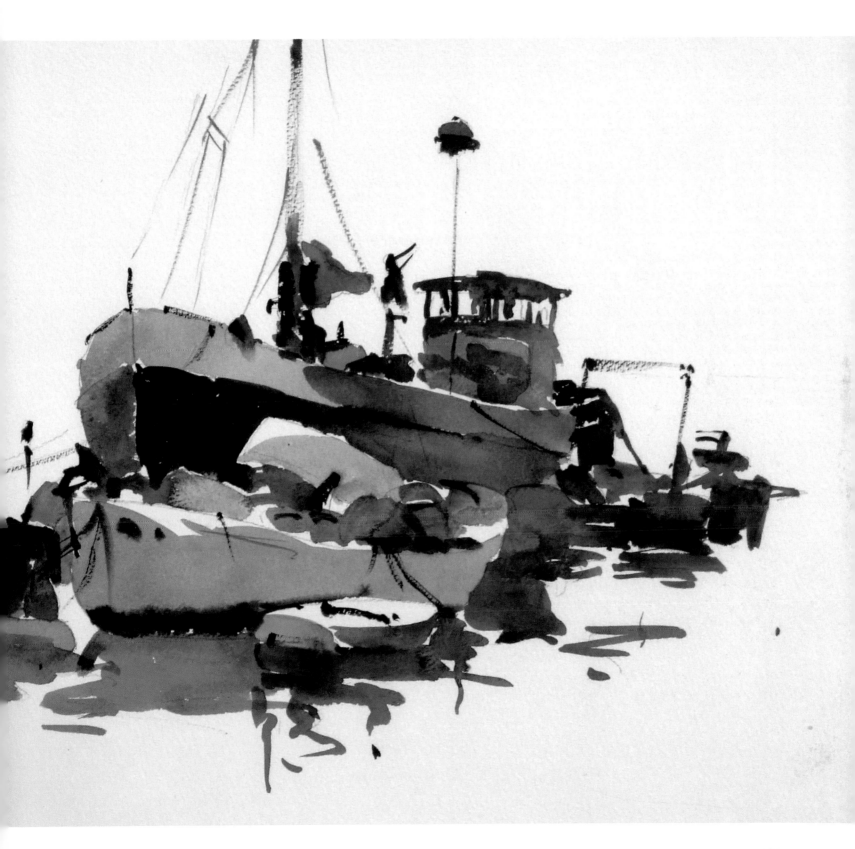

6 DARK TO LIGHT

Most instruction in watercolour painting is based on the traditional 'light-to-dark' painting process. This is how most artists begin with watercolour – by learning how to mix and apply sequential washes of colour to build up tonal and other effects. It is entirely the opposite method to the direct, dark-to-light approach that I use and which is the subject of this book.

You may be thinking that, having started in the traditional way, it must be difficult to work in a completely contrasting way. I accept that it is difficult, but equally I can vouch for the fact that many artists successfully make that change. It was by far the most important and beneficial decision that I made, earlier in my career. And, over the years, I have seen many students on my courses successfully adjust to the dark-to-light approach.

I think that most artists would agree that watercolour is not an easy medium, whichever approach is used. I know that many students find the light-to-dark method incredibly difficult because, in building up successive layers of colour, there is always a danger of overworking a painting and so creating muddy colours – losing the freshness and vibrancy that is so characteristic of watercolours. Also, it can be difficult to judge the pale tones in relation to the white of the paper, yet very easy to lose the white altogether and therefore undermine the impact of tonal contrasts.

The direct, dark-to-light approach requires speed and confidence, but as it is on the whole a 'one-touch' technique, you get fresh colour without the danger of losing the whiteness of the paper where it is needed. This is because you start with all the darks, and then consider the mid-tones, and finally the pale tones (or white areas) are left unpainted. One of the main problems that students have with watercolour is that they are afraid to leave any areas of white paper. My advice is that you should not be reluctant to leave some of the paper white – these areas are very important in creating contrast and impact in a painting.

On the Mud at Binic
watercolour on Arches 300gsm (140lb) Rough
46 x 32cm (18 x 12½in)

I greatly enjoyed painting this subject.
I particularly liked the strong sense of
perspective created by the grouping of
the boats, and the wonderful play of light
and dark shapes.

On location

Beer High Street (page 112), *The Grand Piano* (right) and *Moored at Woodbridge* (page 113) are all examples of subjects that were painted on the spot. I enjoy painting outside, but because I am a professional artist and time is always a factor, it is usually more effective for me to be in the studio. For location painting trips I take a lightweight metal folding easel, a concertina container for water, my usual palette box (the same one that I use in the studio, see page 26) laid out with a fresh supply of each colour, a selection of brushes, watercolour paper stretched on a board, and a carton of water. Don't forget the water!

As discussed on page 65, there are advantages and disadvantages to painting outside, and it does need a certain amount of confidence. Initially, you may want to join a painting group or perhaps ask a painting friend to go out with you. To boost your confidence, try starting with some quick sketches – just using a sketchbook and a pencil or pen. At first, try sketching in your garden or in your immediate neighbourhood before you venture further afield. Just draw what you see. This will be useful practice and of course very helpful for developing your drawing skills. It will also help you to develop an eye for judging the qualities that make a subject interesting to draw or paint. There are good subjects everywhere, but it takes some experience to recognize them.

The weather and the light are always influential factors when painting outside. Much depends on making the most of the different effects of mood and atmosphere that you find, through the use of colour, tone and other qualities. It is essential to work quickly, and this is where the direct, dark-to-light technique is an advantage. Also, because with this method the darks are painted first, it is not such a problem if, after a while, the light begins to change and the tonal values alter. I like to have all my equipment

The Grand Piano
watercolour on Arches 300gsm (140lb) Rough
32 x 46cm (12½ x 18in)

I was invited to paint at a lovely old country house in Somerset, where I found this beautiful grand piano. I decided to paint it wet-into-wet, which I thought would perfectly suit the character and mood of the subject. However, I wasn't prepared for the fact that the paint would not dry due to the cold, damp conditions, and I had to add the final touches back in the studio.

ready and at hand, so that I can put all my concentration into the painting.
I work with the easel at a very shallow angle, starting with a pencil sketch
and then going straight in with colour.

There are no certainties when painting on location: you have to be ready to
deal with the unexpected. For example, I painted *The Grand Piano* (page 111)
at a lovely old country house in Somerset. I thought it would work well as a
wet-into-wet painting, starting with masking fluid to protect the highlights.
It was a damp, cold day and the house was not heated. It wasn't long before
I had most of the painting finished and just needed it to dry before I added
the final touches, including the shadow behind the piano. But because of the
damp atmosphere the painting would not dry – something that had never
happened to me before. So I had to take it home carefully and finish it there!

Beer High Street
watercolour on Arches 300gsm (140lb) Rough
32 x 46cm (12½ x 18in)

As here, the direct, dark-to-light approach is
ideal for painting on location, where speed is
essential.

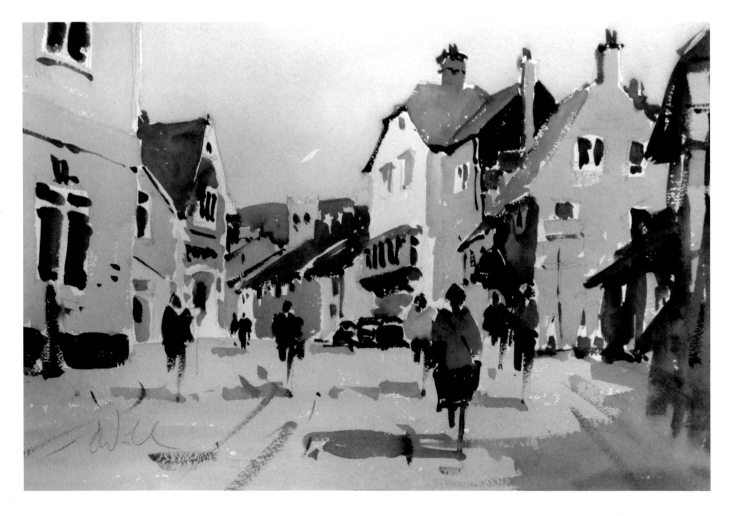

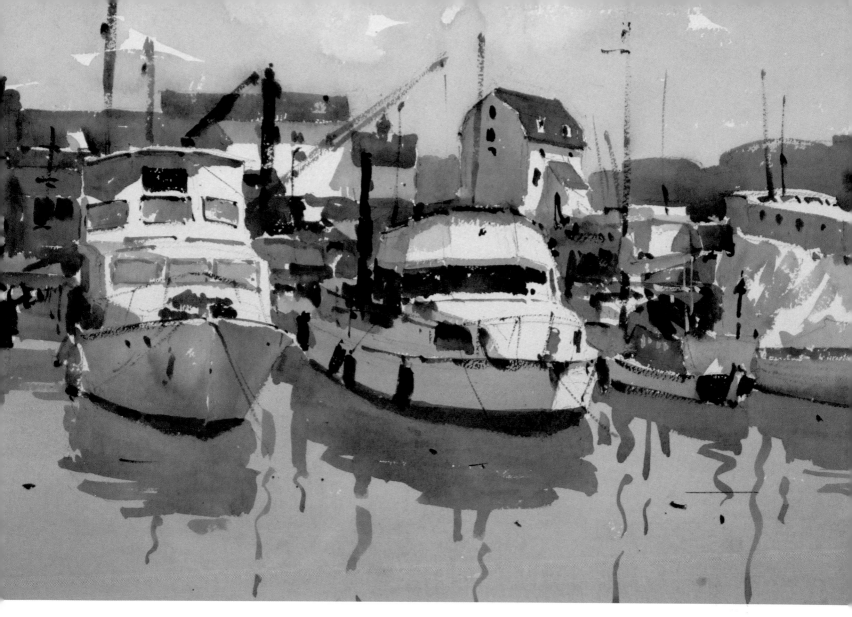

Moored at Woodbridge
watercolour on Arches 300gsm (140lb) Rough
32 x 46cm (12½ x 18in)

I paint at Woodbridge every year, usually with fellow artist John Yardley. This was another fascinating subject to paint, particularly with regard to maintaining the crisp white areas on the boats and buildings, and adding the subtle reflections.

In the studio

Working in a studio is comfortable and familiar. You are not at the mercy of the light and weather, you will not be interrupted by inquisitive passers-by, and everything can be controlled to a much greater extent. Essentially this is an advantage, but there is always a danger that, with no time constraints or any of the other pressures that might be experienced outside, the work might become too considered and consequently look laboured. However, when using the direct method it is less likely that you will overwork a painting, and even if you sometimes paint in the more traditional way, with layered washes of colour, you can reduce the temptation to do too much by taking an occasional break. If you leave the painting for a while and then go back and view it afresh, you will get a better impression of how well it is progressing and what more, if anything, needs to be done.

Step by step: **Roses**

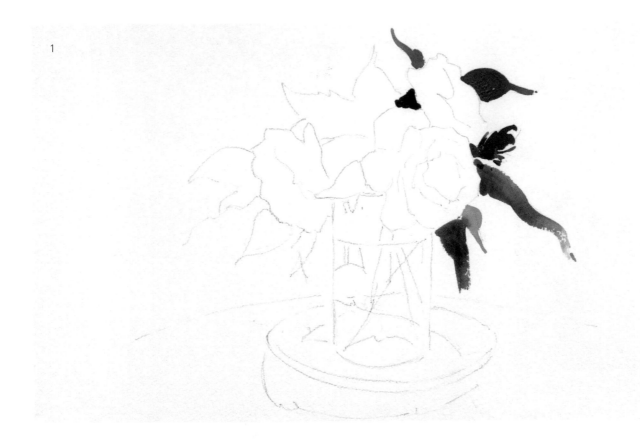

1

In every painting, my aim is to create work that is lively and interesting, and made with integrity, spontaneity and personality. Certainly location painting encourages those qualities; it encourages greater intensity and gives work an 'edge'. I aim to maintain that 'edge' in the studio. For me, a successful painting is one in which it is impossible to judge whether it was painted on site or in the studio.

Studio subjects

Portraits, figure studies, still lifes and flowers are all great subjects to paint in the studio. With each of these, the main factors to consider are composition and lighting, but additionally there may be other more specific points to take into account, such as creating a sustainable pose for your life model, and remembering to give the model occasional breaks. Flowers are

1 First, I wanted to concentrate on the dark shapes around the roses to define the flowers in negative – light against dark.

2 From the initial marks, I worked to complete the leaves, paying particular attention to the shapes, the tonal contrasts and the overall silhouette, rather than detail.

3 For the glass vase, I simplified the shapes and tones, otherwise it would have detracted from the flowers above.

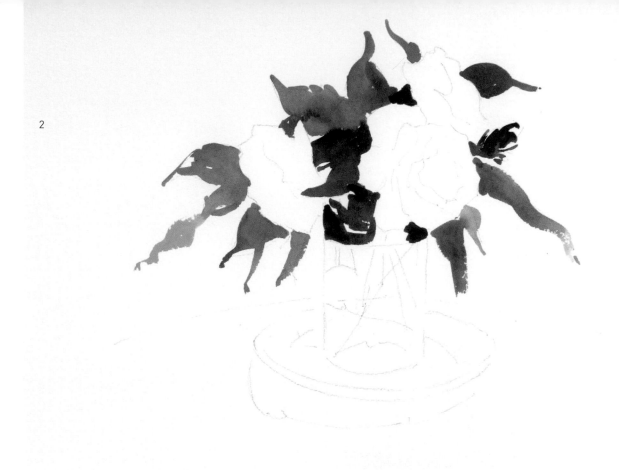

2

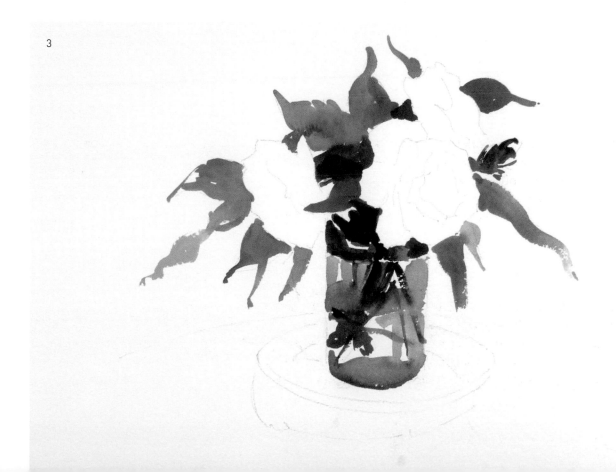

3

4

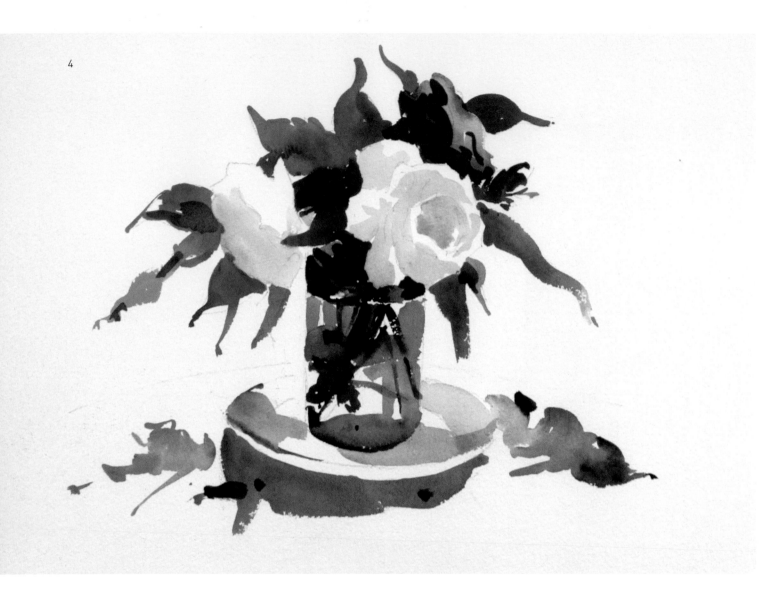

my favourite studio subject: I think they have a wonderful abstract potential, and I enjoy the fact that I can start by placing all the rich darks and so preserve crystal-clear white shapes for the flowers, which I can add later.

With flowers, as with every subject that I paint, my aim is to remain truthful to the subject but to convey it as an impression rather than a highly detailed study. I am not seeking botanical accuracy, showing every subtle colour variation of the petals and every vein on the leaves. And in fact this would not suit my direct, dark-to-light painting method. Rather, I am looking for

4 Next I added the pale tones of the flowers, which I found much easier to judge against the darks of the leaves behind.

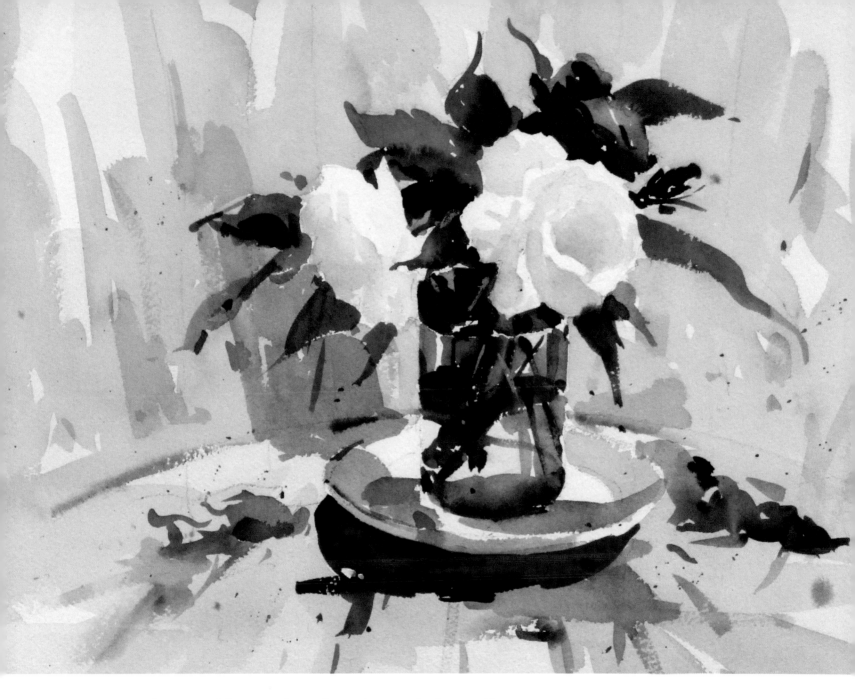

a connected pattern of shapes and an enhanced sense of colour. As I have said, flowers make a perfect subject for exploiting abstract qualities. If you look at flowers through half-closed eyes, essentially what you will see is a series of coloured shapes of different tones and intensity which link together in a certain way.

I usually avoid small, delicate flowers. I like fairly large shapes in my flower arrangements and this means that I often include flowers and leaves that would not normally be seen together. For example, in *Roses* (above) there

Roses
watercolour on Arches 300gsm (140lb) Rough
32 x 46cm (12½ x 18in)

Finally, I added the background, including my 'trademark' directional lines and spattered paint. I was able to add the background last of all, because I had not used any strong, staining colours for the flowers. Staining colours tend to bleed through any washes that are applied over or against them.

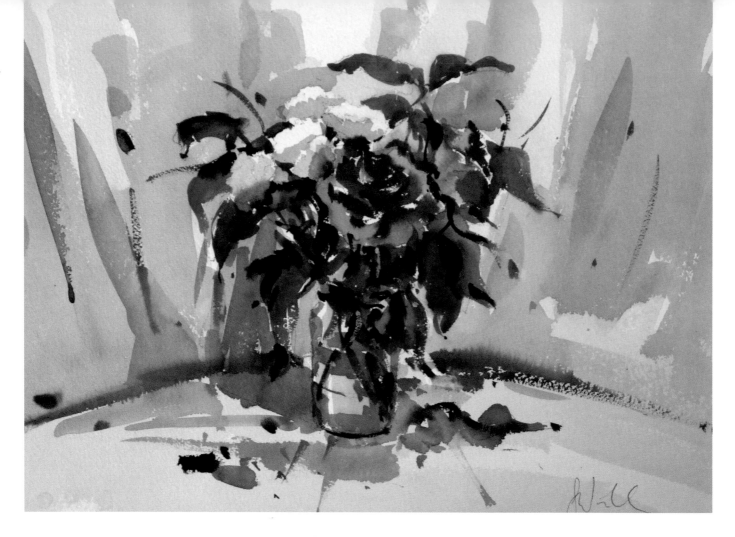

are various leaves that I found in a hedgerow, rather than rose leaves, and I have paired these with roses cut from my father's garden and from a neighbour's garden. I arranged the roses on a table in front of a window so that the light created interesting contrasts between highlights and shadows. My painting position was to the left of the flowers, which meant that I wasn't looking directly into the light.

I started with a pencil sketch and then began to work on the various dark tones of the leaves that surrounded the flowers. I worked with cobalt blue, raw sienna, sepia and alizarin crimson, varying the colours and tonal values, and basically painting the leaves as a continuous connected dark wash. You can see how this developed by looking at stages 1 to 3 (pages 114–115). Note that, at this point, the painting looks quite abstract – just a series of coloured marks that are beginning to define the shape of the roses.

Then, in Stage 4 (page 116), I began to add the pale tones of the roses. It was much easier to judge the pale tones against the darks of the leaves than it would have been if I had started with them against the white of the paper.

Reds and Whites
watercolour on Arches 300gsm (140lb) Rough
32 x 46cm (12½ x 18in)

Again, here you can see that I have concentrated on capturing the general character of the flowers rather than complicating the painting with a lot of detail. In my first DVD, *Watercolour Dark to Light*, you can see a full demonstration of me painting this watercolour.

White Daisies
watercolour on Arches 300gsm (140lb) Rough
46 x 32cm (18 x 12½in)

In my flower arrangements, I prefer large flowers and I often paint white flowers, which have wonderful shadow colours.

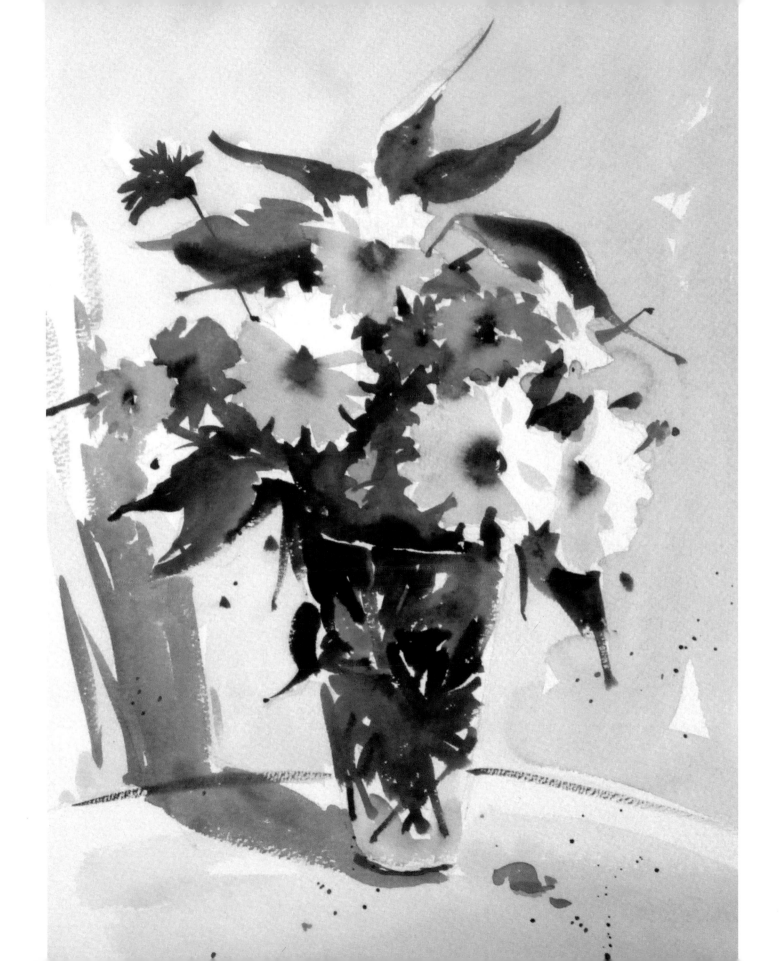

Step by step: Exmouth Harbour

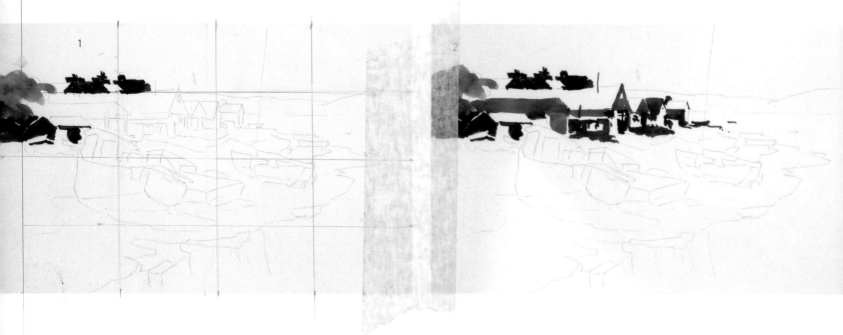

Finally, I added the background wash, a few directional marks in the foreground, and some spattered paint – which is something of a trademark of mine, but it helps to enhance the sense of life and energy in a painting. I often put the background in last with this type of subject. This is partly because I prefer to start with the parts of a subject that most interest me, but also because I don't want to be held up while the background wash is drying. However, as explained on page 117, I can only do this if I haven't used strong, staining colours for the main painting.

1 With the dark-to-light method, you can start with the dark tones anywhere in the painting. As I did here, I often start in the background.

2 I continued assessing and adding the darks and mid-tones, working across the painting.

Darks first

Flower subjects are usually painted from life, of course, but for the vast majority of my subjects I use photographs or sketches as reference material. *Exmouth Harbour* is typical of this approach. In the various stages illustrated on pages 120–122, you can see how this painting developed from a few initial brushmarks into a pathway of darks and mid-tones throughout the painting, through to the addition of the broad background washes and final details.

With *Exmouth Harbour*, the attraction of the subject was its striking composition combined with the potential to use colour. I liked the way that the estuary curved round to lead the eye into the distance and so helped to

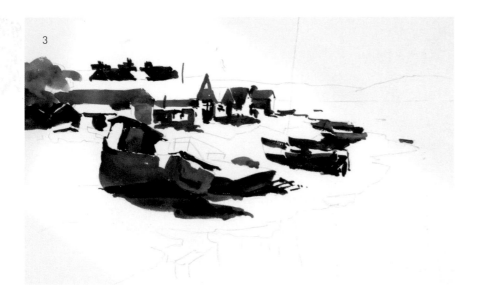

3 From making the first marks through to placing the red boat was essentially all one continuous sequence.

4 After leaving the painting to dry, I added the lighter tone of the beach area.

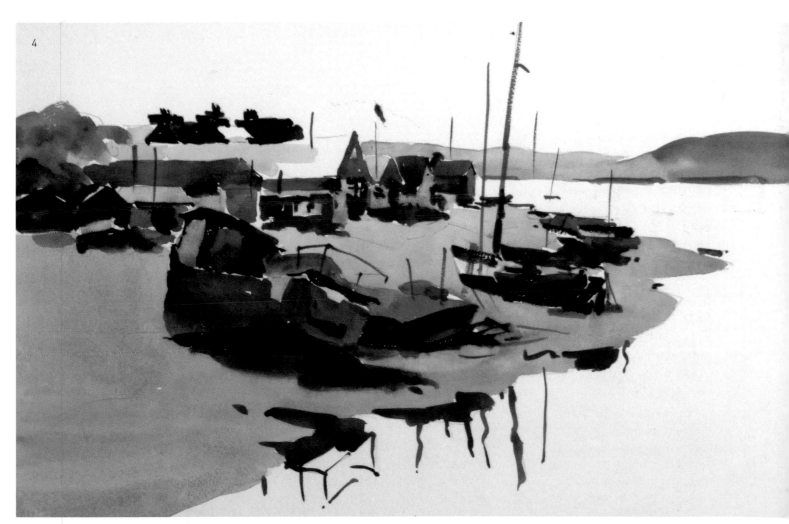

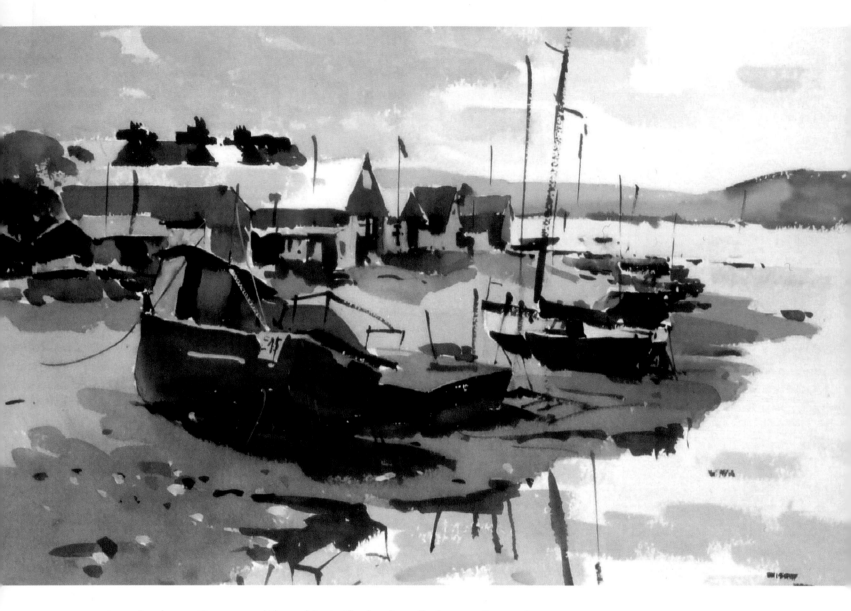

create a circular motion around the subject. The boats pulled up on the mud bank, set against the various buildings behind, created a lot of interesting shapes to work with. It was a changeable day, with sunshine and showers, but I managed to catch the subject during one of the brighter periods and was able to make a sketch and take some photographs.

I particularly liked the way that the sunlight glinted from the roof of the blue building in the background to give a stark white area against the dark trees behind. The tide was coming in, but because the boats were grounded on the mud bank above the water, this didn't cause any problems. Similarly, the reflections of the masts and boats (perfect for adding interest to the foreground) were not much affected by the incoming tide.

Exmouth Harbour
watercolour on Arches 300gsm (140lb) Rough
32 x 46cm (12½ x 18in)

Finally, I added the broader washes for the sky and water areas. I deliberately kept the water very pale in tone, so as to enhance the overall tonal contrast.

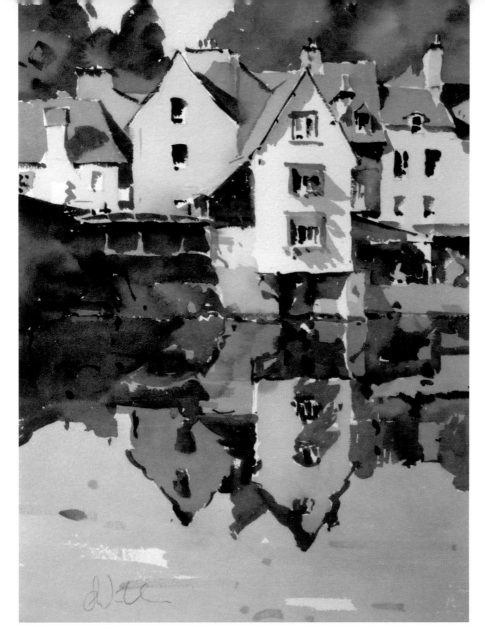

The River Rance at Dinan
watercolour on Arches 300gsm (140lb) Rough
46 x 32cm (18 x 12½in)

Having worked on the top half of this painting, beginning with the dark greens in the background, I turned the painting upside down to paint the reflections, which curiously (and fortunately, because it left a lovely outline of the buildings) did not include the reflections of the trees. Note that a reflection is always more limited in its tonal scale, and more muted in colour than the original.

In the studio, I began with the darks in the background, working across and then down into the foreground to place all the relevant darks and mid-tones in a continuous sequence, as shown in Stages 1 to 3. I let the painting dry and then added the beach area, and finally the water and the sky. I kept the water very pale in tone, to enhance the contrast and drama of light and dark throughout the painting.

From abstract to reality

From the sequence of stages shown in each of these two demonstration paintings, *Roses* and *Exmouth Harbour*, you can see that essentially, with the dark-to-light method, the process involves gradually building up the painting with shapes and colours related to the main tonal values, beginning with a key dark area. Equally, the method relies on an enhanced use of colour,

assured mark-making and, in the main, a one-touch, *alla prima* approach. That is to say that most colours are applied with immediate reference to their finished effect: they are not modified in any way by overlaying them with additional colour washes. In the first stages of this method, the principal concern is to establish connected shapes based on the shadow areas and dark tones, which in turn will begin to define more specific shapes – boats, buildings and so on – revealed as light against dark.

As *The River Rance at Dinan* (page 123) shows, by working in this way you can ensure that the colour is kept fresh and the overall impact is lively and interesting. Initially, with just the dark areas and perhaps most of the mid-tones in place, the painting will look quite abstract – just a collection of coloured marks and shapes with white spaces in between. However, once the lighter tones are added (which are very often the broader, background areas), the painting starts to make sense. There is no danger of losing all the

Grand Canal Gondolier
watercolour on Arches 300gsm (140lb) Rough
32 x 46cm (12½ x 18in)

This painting perfectly summarizes the dark-to-light technique. I painted all the shadow sides of the buildings first, and by so doing each shadow began to define the shape of the next building. As always, I have used a variety of colours applied with brisk, confident brushstrokes.

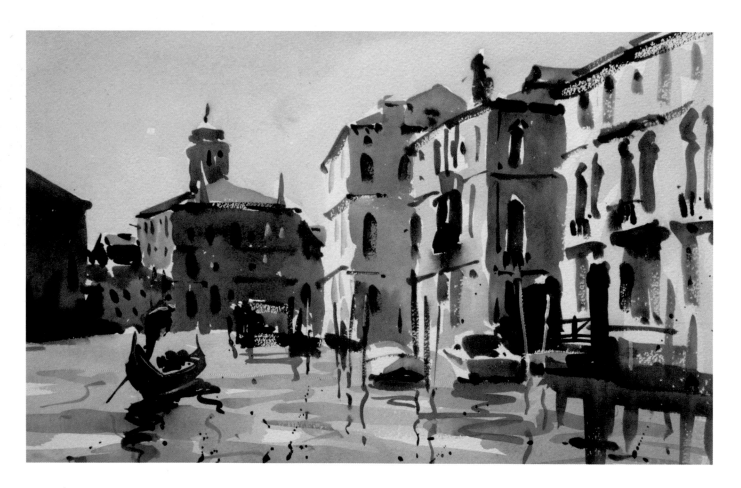

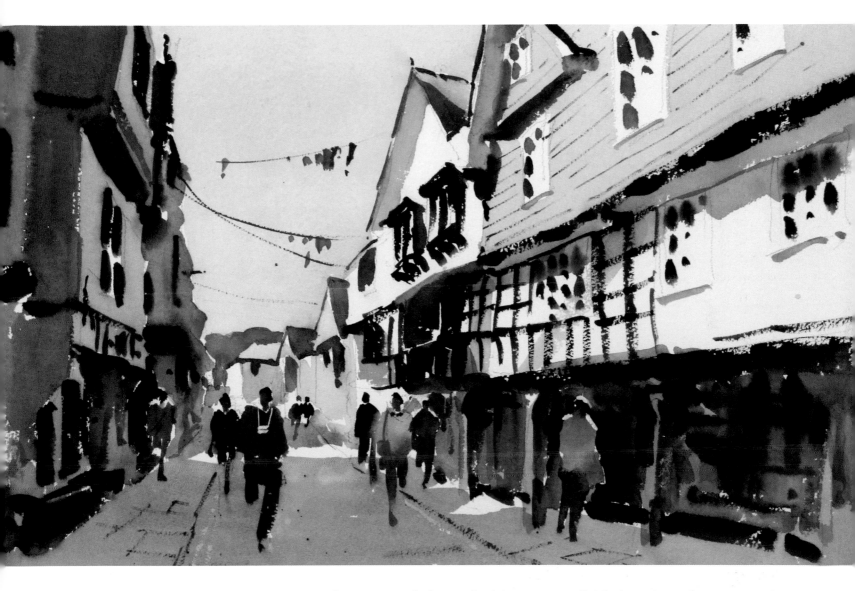

Dartmouth
watercolour on Saunders Waterford 300gsm
(140lb) Rough
32 x 46cm (12½ x 18in)

Working from dark to light will usually ensure
that the colour is kept fresh and the overall
impact is lively and interesting, as in this busy
street painting.

white areas with this method, because you finish the painting by
considering the whites, rather than starting that way. A few details are
added, although details should be kept to a minimum. Essentially, the
painting develops from abstract to reality.

A personal style

There are many reasons why people want to paint, but
I think that usually the main reason is because they have
a strong desire to be creative and express themselves.
However, at first it is difficult to paint in a manner that truly
reflects our feelings and ideas or in a style that we are
happy with, because there is a great deal to learn and,
within that process, a lot of external influences. It is natural
and indeed can be beneficial at first to emulate the
techniques of other artists, but eventually our own
personality will begin to come through. Style is something
that gradually evolves: it is not something that we should
try to impose on our work. With perseverance and
increased experience and confidence, a personal style is
sure to develop.

The surface you choose to paint on, the consistency of the
paint, the type of brush you use and the way that you use
it: these are all important factors that will determine the
character of a finished painting. Also, the subjects that you
are drawn to paint and the qualities within them that you
choose to emphasize will play a part in creating paintings
that have a particular impact. Moreover, every artist works
with an individual sense of perception and type of skill. It is
the combination of all these factors that in time leads to a
distinctive style. With watercolour, perhaps more so than
with any other medium, there is tremendous scope to be
expressive and work in an individual way. In my view the
direct, dark-to-light approach offers a good balance of
control and freedom, and undoubtedly it also allows plenty
of opportunities for the vision and personality of the artist
to enrich the results in a personal way.

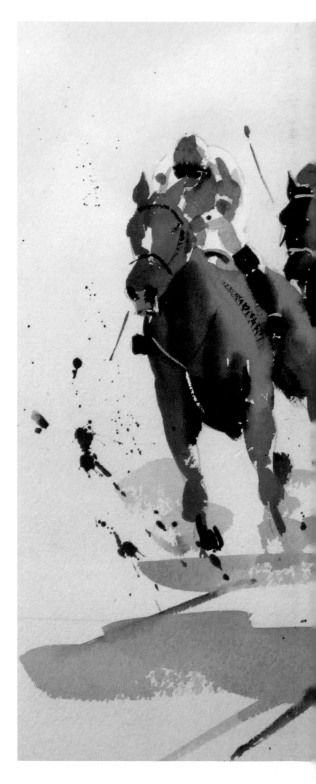

Racers
watercolour on Arches 300gsm (140lb) Rough
32 x 46cm (12½ x 18in)

Here is a painting that typifies my work. I love
trying to capture movement and working with
strong shapes and bold colours.

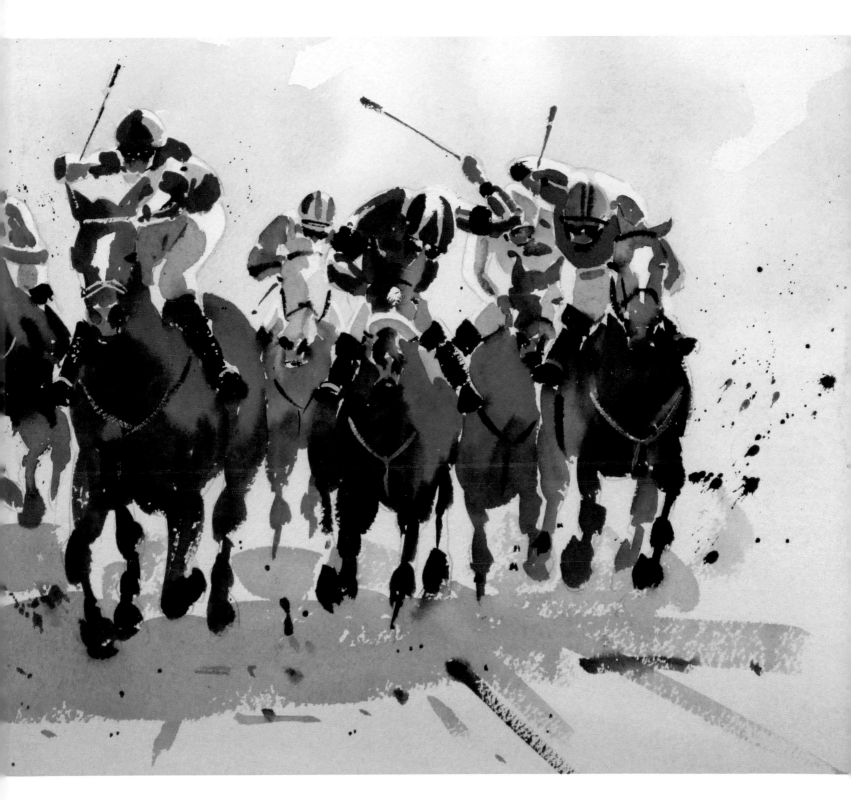

Index

Page numbers in *italics* refer to illustrations